2000

Brice Marden
Work of the 1990s

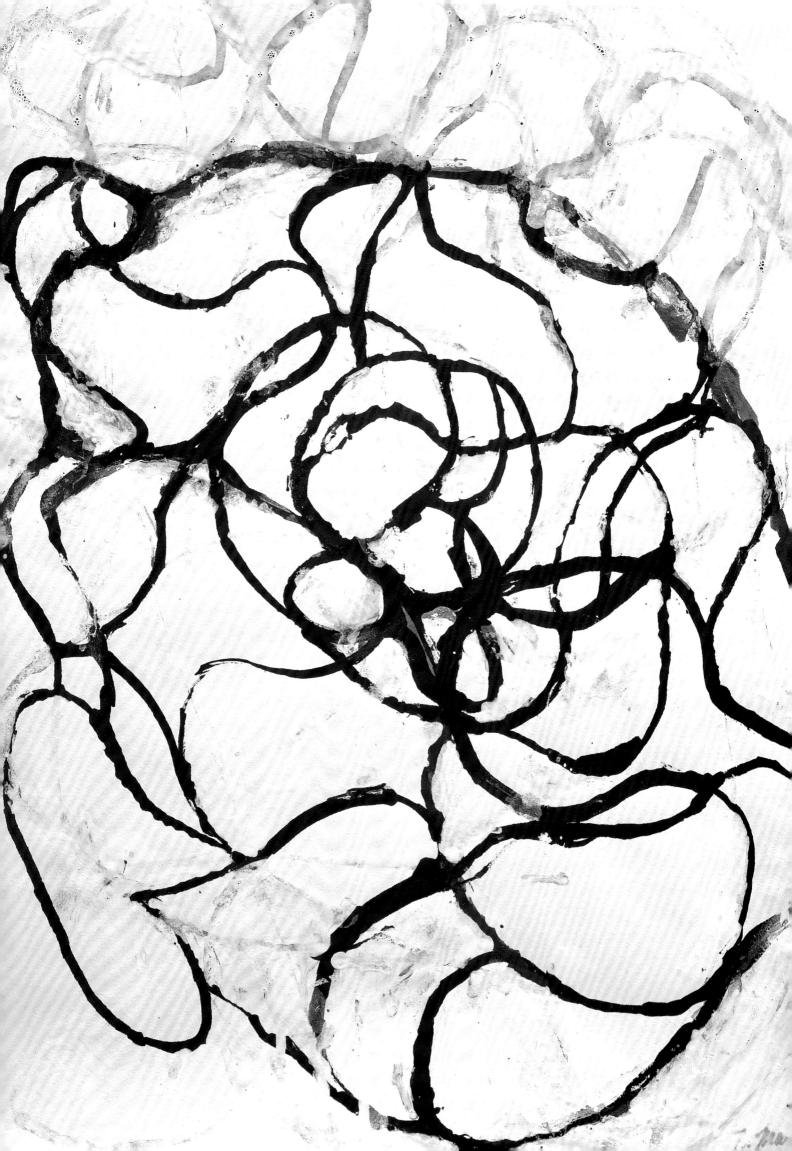

Brice Marden

Work of the 1990s:
Paintings, Drawings, and
Prints

Charles Wylie

Dallas Museum of Art
in association with Distributed Art Publishers

This catalogue has been published in conjunction with the exhibition *Brice Marden, Work of the 1990s: Paintings, Drawings, and Prints,* organized by the Dallas Museum of Art and held at the Dallas Museum of Art from February 14 to April 25, 1999; the Hirshhorn Museum and Sculpture Garden, Smithsonian Institution, Washington, D.C., from May 27 to September 6, 1999; the Miami Art Museum from December 17, 1999, to March 5, 2000; and the Carnegie Museum of Art, Pittsburgh, from May 20 to August 13, 2000.

The exhibition, publication, and accompanying programs are supported by a generous grant from the Chairman's Circle. The print project has been coordinated by Matthew Marks Gallery and Brice Marden.

Available through D.A.P./Distributed Art Publishers
155 Sixth Avenue, 2nd Floor, New York, N.Y. 10013
Tel: (212) 627-1999 Fax: (212) 627-9484.

Edited by Queta Moore Watson
Designed by Ed Marquand with assistance by John Hubbard and Daniel Hale
Produced by Marquand Books, Inc., Seattle
Printed and bound by C & C Offset Printing Co., Ltd., Hong Kong

Debra Wittrup, DMA Managing Editor
Suzy Sloan Jones, Publications Assistant
Cheryl Hartup, McDermott Curatorial Assistant

Front cover: detail from *Study for The Muses (Hydra Version)* (cat. no. 10)
Back cover: detail from *The Sisters* (cat. no. 8)
Frontispiece: detail from *Eaglesmere Set, 4* (cat. no. 28)
Page 6: detail from *Muses Drawing 4* (cat. no. 24)
Page 12: detail from *Cold Mountain 2* (cat. no. 2)

Library of Congress Cataloging-in-Publication Data
Wylie, Charles.
 Brice Marden : work of the 1990s : paintings, drawings, and prints / Charles Wylie.
 p. cm.
 Published in conjunction with an exhibition held at the Dallas Museum of Art and three other museums between Feb. 14, 1999 and July, 2000.
 Includes bibliographical references.
 ISBN 0-936227-25-7 (hard : alk. paper)
 1. Marden, Brice, 1938– —Exhibitions. I. Marden, Brice, 1938– . II. Dallas Museum of Art. III. Title.
N6537.M364A4 1999
760'.092—dc21 98-43431

PHOTOGRAPHY CREDITS:
Roland Aellig, Bern (cat. no. 9 and fig. 4)
D. James Dee, New York (cat. nos. 6, 31)
Bill Jacobson, New York (cat. nos. 2, 3, 4, 7, 8, 10, 11, 12, 13, 14, 15, 16, 17, 19, 20, 21, 22, 23, 24, 25, 26, 27, 28, 29, 30 and figs. 1, 5, 6, 7)
Tom Jenkins, Dallas (figs. 2, 3)
Kurt Markus, Kalispell, Montana (portrait of Brice Marden)
Tom Powel, New York (cat. no. 18)
Adam Reich, New York (cat. no. 1)

Contents

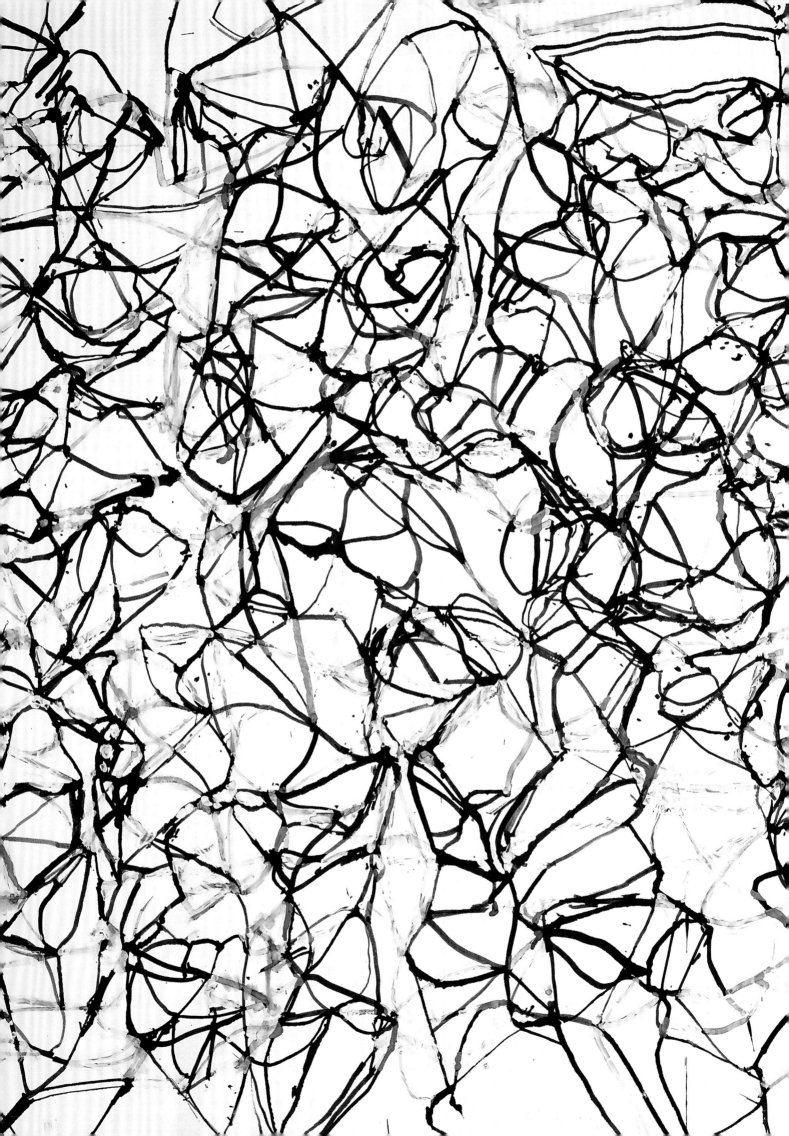

Lenders to the Exhibition

Frances and John Bowes

Irma and Norman Braman

Daros Collection, Switzerland

Mr. and Mrs. Richard S. Fuld, Jr.

Susan and David Gersh

Mr. and Mrs. Stanley R. Gumberg, Pittsburgh

Hirshhorn Museum and Sculpture Garden, Smithsonian
 Institution, Washington, D.C.

Werner H. and Sarah-Ann Kramarsky

Kunstmuseum Winterthur

Robert Lehrman, Washington, D.C.

Brice Marden

Helen Marden

Matthew Marks Gallery, New York

Patricia Phelps de Cisneros, Caracas

David Pincus

Private collection, New York

Private collection, San Francisco

Private collection, courtesy Thomas Ammann Fine Art, Zurich

Kathy and Keith Sachs

The Saint Louis Art Museum

Dr. and Mrs. Paul Sternberg, Glencoe, Illinois

and several lenders who wish to remain anonymous

Organizational Funding Provided by

Linda and Bob Chilton

Dallas Museum of Art League

Adelyn and Edmund Hoffman

Barbara Thomas Lemmon

Joan and Irvin Levy

The Edward and Betty Marcus Foundation

Howard E. Rachofsky

Deedie and Rusty Rose

Mr. and Mrs. Charles E. Seay

Foreword

SINCE ITS FOUNDING nearly a century ago, the Dallas Museum of Art has been very active in the area of contemporary art. Early acquisitions were typically in the form of paintings purchased directly from living artists. Through studio and gallery visits, as well as by attending major events like the Carnegie *International*s in Pittsburgh, DMA directors, curators, and patrons began to build a contemporary collection for the citizens of their city. Years later, in 1963, the Museum's efforts were greatly enhanced when it merged with its sister institution, the Dallas Museum of Contemporary Arts. By combining resources, the DMA emerged with a much enhanced permanent collection and a board of trustees more strongly oriented to contemporary art.

During the ensuing three and a half decades, the DMA has built on this strong foundation. The staff and trustees have sought major works to add to the collection, greatly expanded the amount of gallery space devoted to contemporary art, and invested in dynamic educational programming in the field. And now, as we near the turn of a century again, the DMA is working with Raymond D. Nasher to realize the dream of a garden featuring his world-renowned collection of 20th-century sculpture in downtown Dallas adjacent to the Museum.

Hosting and organizing exhibitions of contemporary work has also been a mainstay of the Dallas Museum of Art. Upon his arrival in Dallas as The Lupe Murchison Curator of Contemporary Art in 1996, Charles Wylie put forth the idea of organizing a traveling exhibition featuring the work of Brice Marden. *Brice Marden, Work of the 1990s: Paintings, Drawings, and Prints* is the result. Although numerous staff members deserve credit for helping the Museum bring this important project to fruition, Charlie Wylie has always been the driving force behind the show. From his close relationship with the artist to his willingness to work diligently to solve the financial problems and venue issues inherent in organizing a major traveling exhibition in the late 20th century, Charlie Wylie has never wavered in his devotion to this effort. For showing such dedica-

tion and energy he deserves our thanks, as does the artist, Brice Marden, for working with Charlie to make this exhibition a reality.

I thank Richard Armstrong, The Henry J. Heinz II Director, Carnegie Museum of Art; Suzanne Delehanty, Director, Miami Art Museum; and James Demetrion, Director, Hirshhorn Museum and Sculpture Garden, Smithsonian Institution, for their institutions' fine commitment to this project.

Finally, I wish to express my deepest gratitude to the members of The Chairman's Circle. Founded in 1996, this group of nine donors made a three-year financial commitment for the express purpose of underwriting exhibitions at the DMA. Howard Rachofsky deserves special thanks with respect to *Brice Marden* for specifically dedicating his contribution to the support of contemporary art exhibitions. Without leadership of this type at the board level, this project and a host of others undertaken by the DMA would not be possible.

Charles L. Venable, Ph.D.

Interim Director

Chief Curator

Dallas Museum of Art

Acknowledgments

THANKS ARE DUE to numerous individuals who have made this exhibition and catalogue possible. I thank Lisa Lyons, Michael Shapiro, and Jeremy Strick for their respect and encouragement regarding this project as well as my professional and personal well-being. While working for Lisa at Lannan Foundation, I came into contact with Marden's great paintings *Rodeo* and *For Pearl*. The Saint Louis Art Museum saw major acquisitions of Marden's work by my senior curators, Michael and Jeremy, and the organization by Jeremy of a select group of Marden drawings into a concise and beautiful exhibition. After defining the basis for the present exhibition with Jeremy, I brought the idea to the Dallas Museum of Art in 1996, where it was enthusiastically received by Jay Gates, former Eugene McDermott Director of the DMA, and Charles Venable, Chief Curator and Curator of Decorative Arts and now Interim Director. I am grateful to the DMA administration for recognizing the importance of contemporary art within a general interest museum.

I appreciate the support and efforts of my colleagues Debra Wittrup, Head of Exhibitions and Managing Editor; Suzy Sloan Jones, Exhibitions and Publications Assistant; Queta Moore Watson, Editor; Kimberley Bush, Associate Director, Collections Management and Museum Operations; and Rick Floyd, Associate Registrar; and my fellow curators, whose projects have provided a daunting measure to live up to. I reserve special thanks for Cheryl Hartup, who came to the DMA as a Marcus Intern from The University of Texas at Austin, and who has remained as the McDermott Curatorial Assistant. Cheryl compiled the biographic and bibliographic sections, and this project could not have been completed without her professionalism, talent, and good humor. Carol Griffin, Curatorial Secretary, also deserves praise for her numerous feats, usually called for at the last minute. I would like to thank Ed Marquand and the Marquand Books team for producing a beautiful catalogue.

I thank Matthew Marks for his unqualified support of this project, for our conversations over the years about Brice Marden and his work, and in particular for his coordination of the print project that has bene-

fited this exhibition. The staff at Matthew Marks Gallery in New York, and particularly Andrew Leslie, Leslie Cohan, Jeffrey Peabody, and Ashley Kern, have performed heroic tasks with humor and efficiency. Doris Ammann of Thomas Ammann Fine Art, Zurich, has been infinitely and graciously supportive of this project as well, and it has been a pleasure getting to know her.

An exhibition such as this is critically dependent on loans from collectors. I am grateful beyond words to all the lenders for their willingness to part with their Marden works for this exhibition and tour, which mark the first time Brice Marden's works will have been shown in these four major museums.

My colleagues Jim Demetrion, Neal Benezra, and Judith Zilczer at the Hirshhorn Museum; Suzanne Delehanty and Sue Graze at the Miami Art Museum; and Richard Armstrong and Madeleine Grynsztejn at the Carnegie Museum of Art deserve my deep thanks for their faith in Marden's work. On behalf of the DMA and personally, I am proud to be associated with these fine people and institutions.

I wish to thank Jenny Monick, who works in Brice Marden's studio. She has been unfailingly helpful and supportive in all manner of crucial instances, providing information and goodwill along the way.

For Brice Marden, of course, I reserve my deepest gratitude. Brice has never been anything but open, good, and engaging in all of our conversations, whether in person or by telephone. Seeing Brice Marden in his studio and elsewhere over the last five years, and having had the privilege of getting to know him, I have been reminded of a phrase beloved (and once used as a title) by Henry James: "the real thing." I thank Brice not only for his work (which has evolved with a profound resolve and integrity) and for his kindness and frankness, but for the chance to witness such a "real thing" in action. There are, of course, other real things in the world, but one doesn't usually get the chance to engage them for so long and on such a significant level. For that I will always thank Brice Marden.

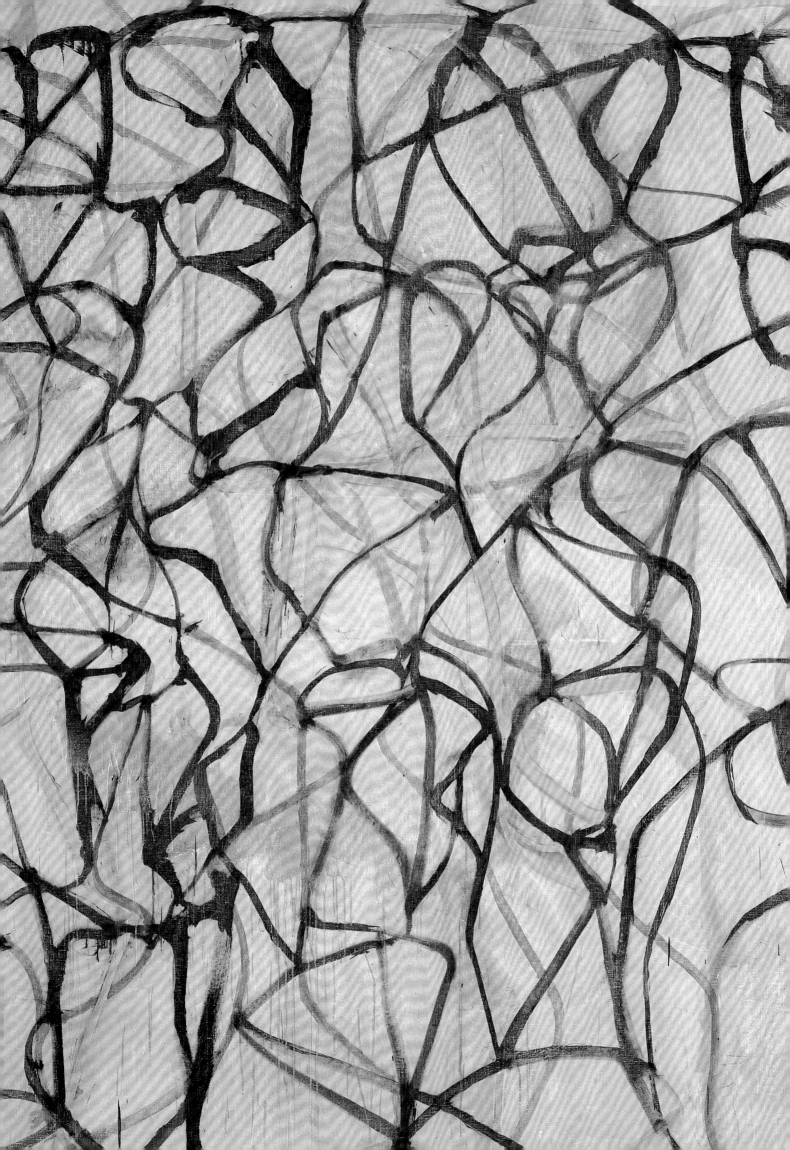

A Spartan Humanism:
Brice Marden's Work of the 1990s

Still, I am conscious now that behind all this beauty, satisfying though it may be, there is some spirit hidden of which the painted forms and shapes are but modes of manifestation, and it is with this spirit that I desire to become in harmony. I have grown tired of the articulate utterances of men and things. The Mystical in Art, the Mystical in Life, the Mystical in Nature—this is what I am looking for. It is absolutely necessary for me to find it somewhere.

—Oscar Wilde, *De Profundis,* 1905

If it ever gets done, this painting will explain to me what I've been doing the past decade.

—Brice Marden

While ten years in the work of any artist is bound to contain its share of shifts and changes, the 1990s has been a decade of continual and profound metamorphosis in the art of Brice Marden. Yet typically for this famously reserved artist, the changes are subtle, the means quiet, and the results (sometimes literally) veiled. Looking for these changes in Marden's work of the 1990s requires a certain amount of tenacity—what one of Marden's essayists has called "sustained analysis and prolonged concentration"[1]—that yields a surprising narrative of astonishing range. The beginning of the 1990s sees Marden completing his landmark *Cold Mountain* series of paintings and starting work on the first in a trio of paintings that will come to be known collectively as *The Muses,* the first of which is based on the Chinese calligraphic practice Marden had adapted for himself in 1985.

Around 1993 Marden will begin to create paintings that are boldly assertive in breaking free of these calligraphic rules, and such freedom will carry through the rest of the decade. The first *Muses* painting, spectral and haunting, will give way to a second version much more rounded

and frankly joyous by 1997, while the third *Muses*, which is in progress as this essay is being written in July 1998, will no doubt yield its own secrets as to where Marden's art will head in the future. Neither hushed and muted nor riotous and hot, as are its two *Muses* sisters, the third *Muses* is leafy green, stalky brown, and coolly royal blue-purple. Yet this will change before the work is seen in its final state. Marden says: "There's something there that starts to look okay if you look at it enough—but the entire energy of the painting is off when I go into some areas of it, and I'm not sure where to get to to fix it. So I'm working on that."[2]

When viewing a group of 1990s Marden works, one needs to be as tenacious as Marden himself because the artist has limited himself to a small number of aesthetic options. The basic elements of a 1990s Marden can be detailed quite quickly—swirling lines crisscrossing a flat surface, either paper or canvas, to create interlocking structures of relative opacity or transparency. In Marden's paintings of the 1990s, shifts in color abound, from icy grays and blues to hot reds, yellows, and oranges to earthy greens and browns. Lusty color itself makes an appearance in his later 1990s prints and drawings, media which Marden had previously limited to the black of ink and the gray of graphite laid down on the white of the paper, while Marden's 1990s strokes and marks can be crabbed or smooth, spiky or fluid, thick or thin, retiring or aggressive.

Marden dramatically varies the dimensions of his canvases, as well as the scale of his imagery within the planes of those canvases, creating paintings both mural scaled and intimate and drawings and prints that take on the authority of paintings. Marden's imagery across the decade suggests a broad diversity of sources, from human bodies to vegetation to cellular structures and other various anatomical references.[3] In short— and perhaps it is simplistic to say so—even though Marden uses the same basic elements for his work of the 1990s, each painting, drawing, and print possesses its own character, tone, and aspect. Given the relatively little amount of work Marden produces, and the relatively small number of works in this exhibition, such a statement may not be as simplistic as it sounds, as it suggests Marden's singular achievement in imbuing the traditional media of oil on canvas and ink on paper with remarkable energy and unmistakable identity.

As in all the work he has produced since his career began in the mid-1960s, Brice Marden has in the 1990s explored new ways to use color and line to register in a resolutely abstract manner his responses to the private/public, personal/professional worlds in which he exists. Yet while the ideas behind twentieth-century abstraction remain paramount to Marden, he has created paintings, drawings, and prints in the 1990s that rely heavily on, and outright depict, the human figure. And in general in the 1990s, Marden has been working more intuitively, laying down lines on his canvas and paper in a manner much more spontaneous and free.

The lines themselves have become fewer in number and have grown more rounded, thicker, and more opaque as Marden has shifted from

using the wrist, hand, and arm to engaging the entire sweep of the body in creating his figures. Marden's use of color in the 1990s has likewise changed, with a new chromatic wave of intensely hot, dense, and high-keyed colors providing new means to express new subjects. In contrast to many of his 1980s and early 1990s works, Marden has in the later 1990s explored the idea of blank space, effacing paint and line or leaving entire areas of his canvas and paper serenely empty.

That Marden often allows space in his 1990s works to be so free and empty testifies to the confidence he feels in his stronger, more forceful line that marks out this space. Rather than filling up the plane of the canvas or paper with a range of energetic linear forms as before, Marden has let the composition seemingly come together according to its own rules in a transparent field of uniform color. Such confidence to let intuition and impulse run free (or at least freer than they ever have with this artist) is typical of Marden in the 1990s and is a natural, and undoubtedly rewarding, result of Marden's hard-won battles to forge a new way to make art in the mid-1980s.

Along with the undeniably ambitious and accomplished body of work he has produced in the 1990s, Marden's confidence, or at least his dogged persistence, especially coming after such doubt,[4] is perhaps one of the reasons he is regarded so highly by so many peers and professionals. Judging from the late 1990s, it seems Marden was right, and has been so all along, as he has continued to find ways to make his work, and painting as a discipline, appear perpetually inevitable.

TWO POETICS

The beginning of the 1990s saw Marden completing *Cold Mountain*, a pictorially restrained and ascetic cycle of paintings, drawings, and prints inspired largely by the poetry (both words and characters) and life of eighth-century Chinese poet Han Shan (Eng.: Cold Mountain). This important series, exhibited in the United States and Europe from October 1991 to June 1993,[5] definitively summarized the work Marden had been making since 1985 under the twin influences of traditional Chinese calligraphy and the radical spatial and technical innovations in painting by American artist Jackson Pollock (and, as always with Marden, Cézanne).[6] The 1988–91 *Cold Mountain* series is justifiably renowned and has played a defining role in Brice Marden's post-1985 work.[7]

Cold Mountain 2 (cat. no. 2) and *Cold Mountain 4* (cat. no. 3), like all the *Cold Mountain* paintings, drawings, and prints, contain a specific interior structure that Marden has artfully obscured with his commanding draftsmanship. Marden laid onto his canvases a linear groundwork gleaned from Chinese calligraphy, a strictly ordered set of rules Marden carefully observed. Chinese calligraphers would start in the upper right-hand corner of their paintings and work left and down, spreading their characters across the picture plane in columns. The characters in Marden's paintings are of his own invention and become webs that

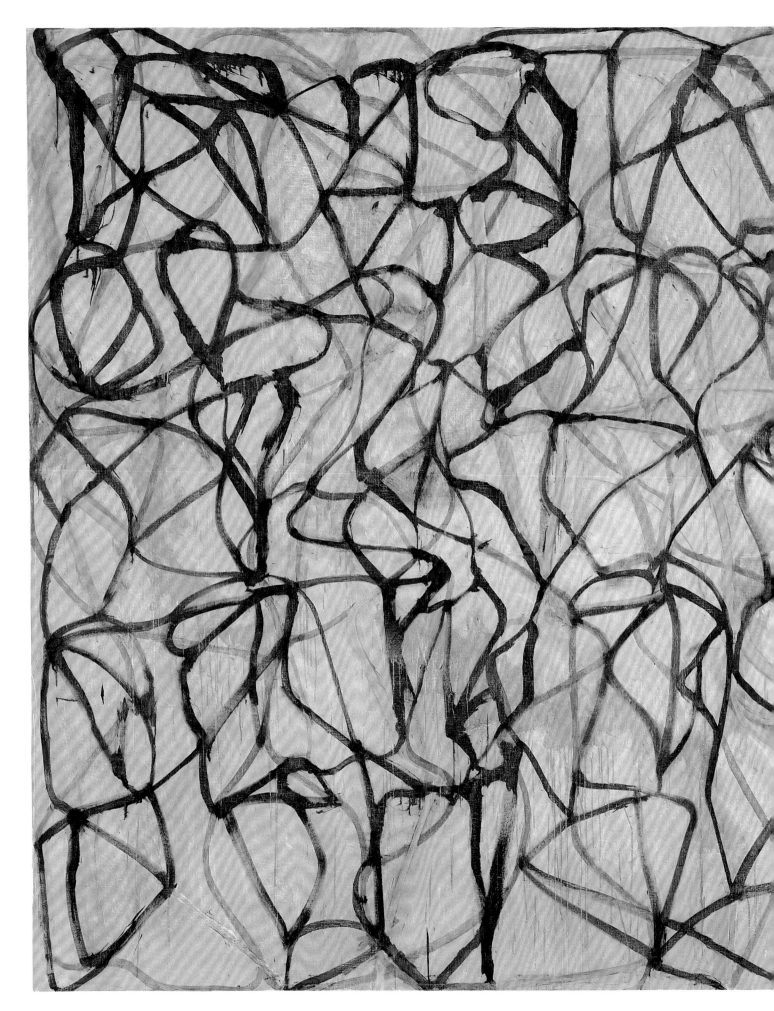

2. COLD MOUNTAIN 2, 1989–91. Oil on linen, 108 × 144 in.
Hirshhorn Museum and Sculpture Garden, Smithsonian Institution,
The Holenia Purchase Fund, in memory of Joseph H. Hirshhorn, 1992.

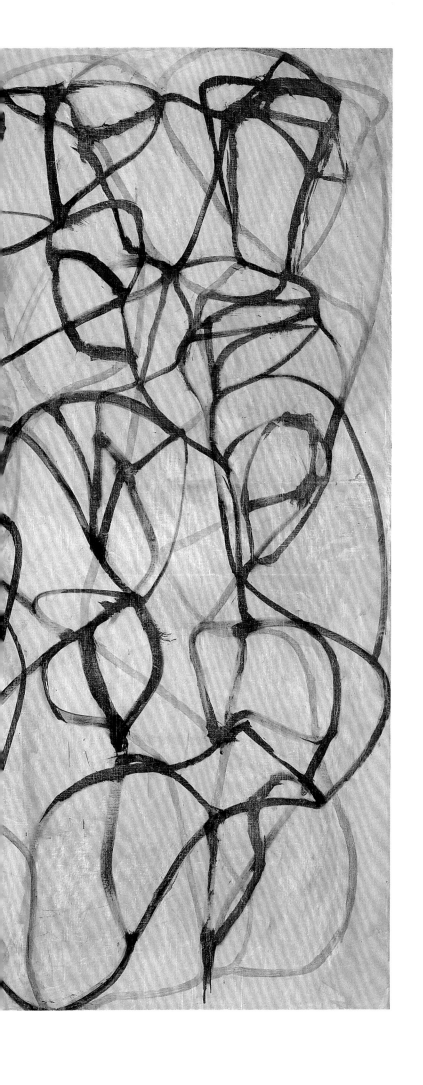

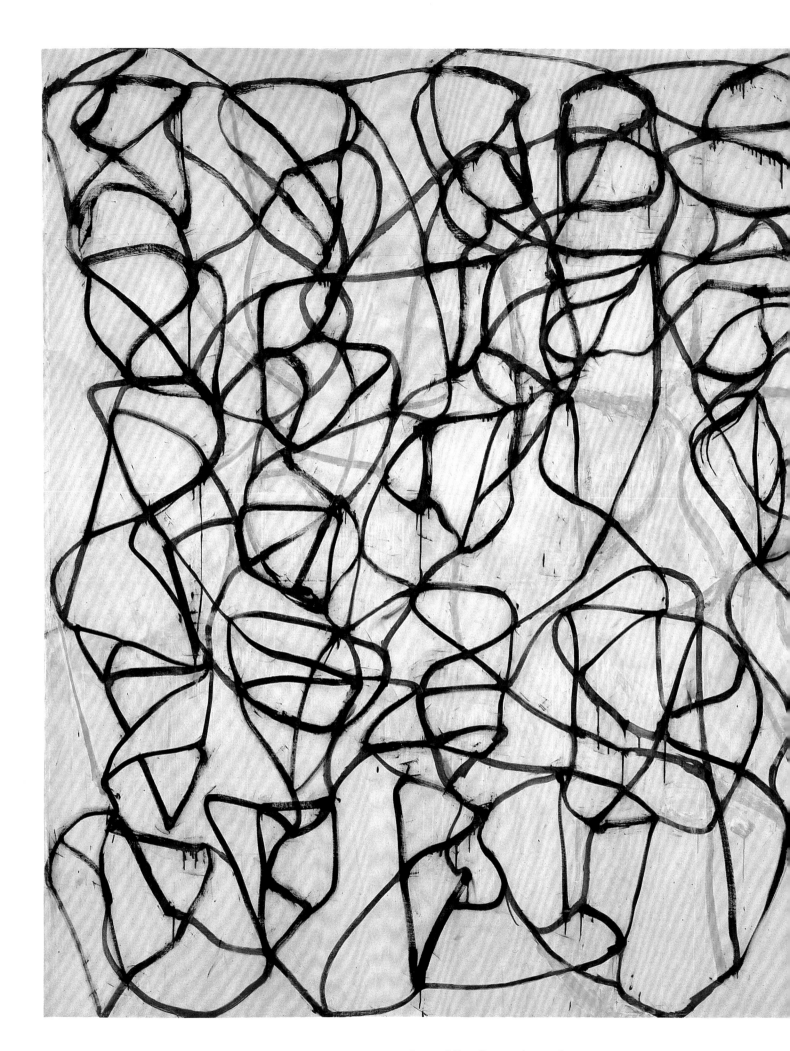

3. COLD MOUNTAIN 4, 1989–91. Oil on linen, 108 × 144 in.
Collection of Irma and Norman Braman.

intertwine, creating complicated relationships between one area of the canvas and the next. Figures, whether human or letterlike, are in fact merely suggested and not defined. Marden created a gray atmospheric background in *Cold Mountain 2* and allowed his paint to smear and drip across the plane, concerned less with perfection than with process. In further testament to Marden's allowing process to play a commanding role in the nature and character of his work is the drawing *Cold Mountain Addendum II* (cat. no. 25), in which the artist has obliterated entire sections of linear structures to create the dynamic union of movement and figure that unites all *Cold Mountain* works. These include the series of etchings *Cold Mountain Series, Zen Study 1–6* (cat. no. 31), in which Marden's full command of the etching process is evident in the increasingly complex composition, which never loses its rigor despite its intricacy.

In trying to delineate the figures we see before us, our eyes connect the columns—as Marden did with his brush using subtly differing pigments and strong solvents—and we become almost unconsciously engaged in the dynamics of composition and background and interaction that Marden seems so effortlessly to compose. The background of *Cold Mountain 4* is brighter and more even; there is less variation in the brush stroke, and the color range is limited to what appears to be a black and gray scheme, creating a sense of relative order and stability. However, its figures appear less integrated with each other, less close and intertwined than those in *Cold Mountain 2*, and the atmosphere is decidedly drier and less complex. Such a brief comparison of the relative human-centric content of these two *Cold Mountain* paintings suggests how adept Marden is at injecting a psychological charge into abstraction. In referring to his

25. COLD MOUNTAIN ADDENDUM II, 1991–92. Ink and gouache on paper, 27⅞ × 34⅜ in. Private collection.

31. COLD MOUNTAIN SERIES, ZEN STUDY 1–2, 1991. Etching, aquatint, sugar-lift aquatint, spit-bite aquatint, and scraping, 21 × 27½ in. (plate), 27½ × 35¼ in. (sheet), edition of 35. Matthew Marks Gallery, New York.

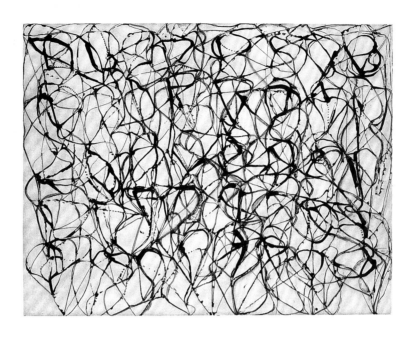

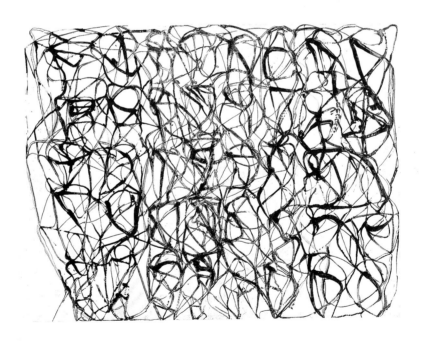

31 . COLD MOUNTAIN SERIES, ZEN STUDY 3–4, 1991. Etching, aquatint, sugar-lift aquatint,
spit-bite aquatint, and scraping, 21 × 27½ in. (plate), 27½ × 35¼ in. (sheet), edition of 35.
Matthew Marks Gallery, New York.

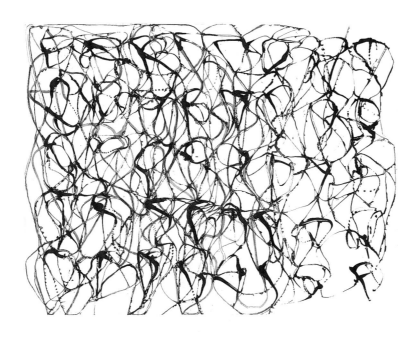

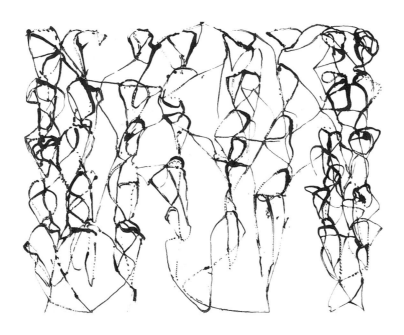

31. COLD MOUNTAIN SERIES, ZEN STUDY 5–6, 1991. Etching, aquatint, sugar-lift aquatint, spit-bite aquatint, and scraping, 21 × 27½ in. (plate), 27½ × 35¼ in. (sheet), edition of 35. Matthew Marks Gallery, New York.

———

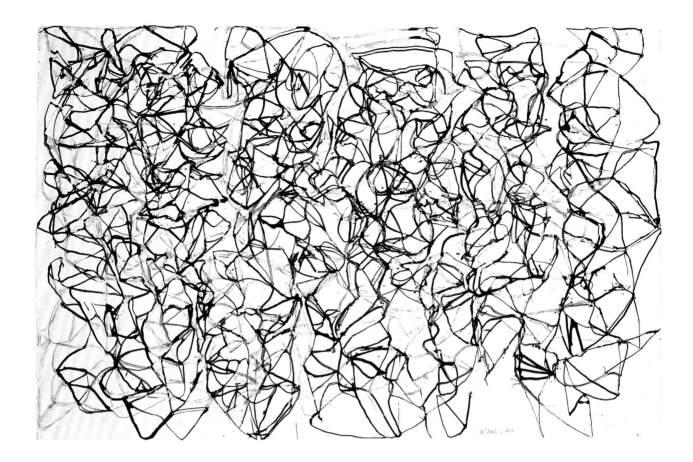

pre- and post-1985 styles, Marden remarked: "One of the reasons I wanted to do this work was that by using the monochromatic palette in the past basically all I could get were chords. I wanted to be able to make something more like fugues, more complicated, back-and-forth renderings of feelings."[8]

Marden states: "The reason I became interested in calligraphy is that in the West we have no equivalent to it—I mean, calligraphy is a codified way to communicate using something supremely aesthetic. In the West we don't have a way to do that."[9] Marden's sense that the aesthetic is part of the everyday in the China of Han Shan, and of other poets and artists from Chinese history that he admired, is but one of the reasons Marden turned to Asian art. Suffice it to say that Han Shan, as poet and human, provided Marden with a powerful example of both aesthetic rigor and personal inspiration.

The success of Brice Marden's *Cold Mountain* series has perhaps obscured the fact that Marden has continued to look not only to China but also to Greece as part of his ongoing investigations into the art and cultures of the past. Han Shan led Marden up the slopes of Cold Mountain, while the Greek myths introduced Marden to the Muses. In 1991, while he was still at work on his *Cold Mountain* paintings, Marden began the first of his three large-scale 1990s paintings based on the Muses, mysterious goddess sisters who lived on the highest mountaintops in ancient Greece and who are mentioned in the earliest Greek mythologies. The

24. MUSES DRAWING 4, 1989–91. Ink and gouache on paper, 26 × 40⅝ in.
Brice Marden.

Muses' role is to spur humans to make art, first by provoking memory and then by inspiring the creative act.

The Muses, children of Zeus, king of the gods, and Mnemosyne, goddess of memory, are nine in number, representing variously the arts of lyric, sacred, and epic poetry; dance; music; history; and astronomy.[10] Marden was prompted to think about the Muses by Robert Graves's account of them as bacchanalian revelers. Marden says: "I remember reading Graves and he talked about these bands of reveling, orgiastic maenads that conducted these wild, primal dances in the forest. Later they became the Muses. I was more interested in their early stages, and that's where the first *Muses* painting came from."[11]

Marden began a group of *Muses* drawings in 1989, including *Muses Drawing 4* (cat. no. 24). In this drawing, Marden uses the unique properties of ink on paper to invoke the presence of his figures in an astonishingly complicated structure that he never allows to become overcrowded or random. The tautness of the composition is formidable, Marden's control extraordinary. In further thinking about the Muses as subject, Marden began, perhaps surprisingly, a fifteen-foot-long painting according to calligraphic rules in 1991; by 1993, when it was finished, it had become *The Muses* (cat. no. 9),[12] in a remarkable instance of Marden using Chinese calligraphic structure for a classical Greek subject. Here the two distinct cultures with which Marden has had the most contact and experience meet in a single painting: Chinese form embodies Greek content, and vice versa.

Also in 1991 Marden embarked on a second and third *Muses* painting, *Study for The Muses (Hydra Version)* (cat. no. 10) and *Study for The Muses (Eaglesmere Version)* (cat. no. 11), which occupied him over the next six to seven years.[13] Marden is currently at work on *Study for The Muses (Eaglesmere Version)*, which was shown in a radically different state as *February in Hydra* (fig. 1) in the *1995 Biennial Exhibition* at the Whitney Museum of American Art, New York. This third *Muses* painting will be seen in its final form in Dallas when the present exhibition opens in February 1999. The *Muses*, then, as idea, form, and inspiration, span Marden's entire career of the last ten years.

Marden's 1991–93 painting *The Muses* conveys what it might feel like to come across the nine goddesses of Hesiod's poem *Theogony* as they conduct one of their ritualistic dances on a mist-covered mountain in Greece some three thousand years ago. The painting is ghostly in theme and color and in the curious evasiveness of its over life-sized imagery. *The Muses* suggests a frieze of figures that progress across the large horizontal plane, moving in stately rhythm and apparently formed from muted lines of gray, blue, green, and brown within the palest of gray-green atmosphere.

Spectral yet energetic, the Muses are summoned but not defined by Marden's brush strokes, which are here thin, there assertive, here thicker, there barely visible, with many lines appearing effaced and often entirely

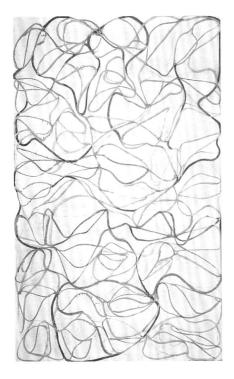

Fig. 1
FEBRUARY IN HYDRA, 1991–94.
Oil on linen, 135 × 83 in.
Early state of *Study for The Muses
(Eaglesmere Version).*

obliterated. Rounded forms at the top edge of the canvas imply heads inclining toward one another, while in the middle section of the canvas torsos and arms seem to bend and sway in animated gesture. At the bottom third, we sense the movement of draped and bare legs, while at the left and right edges of the painting bent elbows seem to push against the limits of the canvas itself.

As soon as we try to fix certainties of anatomy and gesture in *The Muses*, these certainties evaporate. In lieu of instant recognition, we must follow Marden's tantalizing and sinuous lines where they lead, join, and split off. And we become aware that, like the inspiration itself the Muses are said to spark, these transparent figures will forever remain beyond our complete and unambiguous grasp. Marden's imagery forms and then dissolves before us like smoke in a transfixing and challenging exercise of vision and cognition. A Marden scholar and enthusiast has written, "You are a prisoner in a net of details, but you are hooked; the pleasure, an acquired taste, is addictive."[14] Indeed the composition is so involved that the figurative interpretation may not even be the most apt one at all.[15] While visual certainty is (intentionally on the artist's part) impossible here, the effort of fixing such certainty is an intensely rich and gratifying occurrence, one that happens over and over again in Brice Marden's work of the 1990s, and one that nearly defines what it is to have a truly profound aesthetic experience.

Brice Marden's paintings, drawings, and prints of the 1990s all follow in the history of abstract art that necessitates more than a passing glance—as has all of Marden's art even since the 1960s, when his work looked very different than it does today. To "get" Marden's works from any period, the viewer must let the works work on her or him and engage in "sustained analysis and prolonged contemplation"[16]—and, importantly, the viewer must be receptive to the somewhat novel (in our day) experience of standing still to let a painting, drawing, or print become an intensified field for private deliberation, and introspection, and feeling.

GREECE AND MARDEN'S WORK UNTIL 1985

Marden's longtime involvement with Greece and its history, mythology, and landscape began in the early 1970s with his first visits to, and then residence on, the island of Hydra in the Aegean Sea. Marden has instinctually involved himself with classical Greek civilization, seeking relevance in Greek antiquity and the Greek landscape for his own art and life. He has read widely in ancient Greek mythology, a world remote in reality but ever present in meaning, in which the complexities of human experience are related in terms fantastic and entertaining yet unerringly truthful and real. Marden has studied firsthand ancient Greek architecture and sculpture and has even used a number of postcard reproductions of Greek works of art in a series of collage drawings titled *Souvenirs de Grèce* that he began in the mid-1970s and reworked in the 1990s.

Marden's *Grove Group* series of five paintings is probably the best known of the artist's works based on the concept of Greece. These paintings were first seen together at an exhibition at the Gagosian Gallery in New York in 1991 and were inspired by Hydra and its place in the Aegean Sea.[17] In these works, the colors of blue and green predominate, and Marden's deft application of oil and wax allows the viewer to experience nearly firsthand a sense of captured sky, light, land, and ocean. Similar to *The Grove Group* is Marden's painting *To Corfu* (fig. 2), a four-panel work from 1976, part of yet another series but inescapably related to *The Grove Group* in color and theme. Here the painting's simple elements of two blue panels and two green panels resonantly play off one another in representing the experience of a journey Marden took to Corfu by boat from Hydra in 1975.[18]

If *The Grove Group* and *To Corfu* exemplify most clearly Marden's earlier work in relation to Greece, they are also representative of the kind of work, based on the single or joined panel of a single color, that gained Marden his initial enthusiastic renown in the mid- to late 1960s. Marden's paintings of these years have come to be seen as some of the most important of their time for the way in which they suffused basic, even austere forms found in minimalist art—an art at least partly based on the precision of machine-made aesthetics—with a degree of human presence.[19] In 1966 Marden's first exhibition was held at the Bykert Gallery, New York, where his large-scale canvases of muted colors that register as emanations of individual experience were first seen as a group.

Marden's stated goal at the time was to use the least number of artistic elements to bring about the maximum effect—"in a highly subjective state within Spartan limitations."[20] In the paintings of these years, such as *Nico Painting* (private collection) and *The Dylan Painting* (private collection, New York), both 1966, and *No Test*, 1968–70 (fig. 3), Marden mixed oil with wax and applied this mixture to the surface of a canvas to register, simply put, how he felt about a certain person, place, or situation. Color and texture were for Marden the most effective means to achieve his ends. The apprehension of color and surface provided the sensation most equivalent to thinking about a person, for instance, or seeing a stretch of landscape.[21] Because Marden offered his viewers both a field of color that seems to possess an inner core of being and a sensuous, tactile covering, his audience could also experience his emotional pitch about a certain subject found in real life.

The late 1960s and 1970s saw further developments of the monochrome panel, where Marden either literally joined panels together for further expressive effect or placed them side by side as in *The Seasons* (The Menil Collection, Houston), a four-panel work from 1974–75. Here the four seasons of the year are represented by Marden's chosen colors. While no order is given, it is easy to determine that the light green corresponds to our notion of spring, while the richer, darker green next to it relates to the full-grown aspects of summer; fall is gray while winter

becomes darker gray. Simply installed on a gallery wall, Marden's painting reverberates with an inner light that re-creates his own memory and impression of what the seasons have been for him, and what the colors might look like that correspond to that memory. The seasons as a subject have a long history in art, having been personified and represented as various human and godlike figures throughout the ages. Here Marden uses sense and perception to render the various times of the year in a manner wholly of our own time.

SHIFTS AND REVISIONS/CHINA

Marden's shift from using monochrome panels, a strategy based on the rigors of rectangular structures and elemental color, to exploring the energies and dynamics of line and gesture as seen in the 1990s work in this exhibition is a story of complex aesthetic and personal revolutions. Simply stated, a Marden from 1995 looks radically different from a 1966 Marden. That Marden changed his course and revived his own sense of purpose in making art is one of the most compelling stories of recent art history, a story that has been told numerous times in the popular press[22] and in Marden's exhibition catalogues. The appeal of Marden's story is not hard to discern: it illustrates the ability of human beings not only to remake their lives and work but to thrive and excel in the act of doing so.

Throughout the mid- to late 1970s and early 1980s, Marden continued to rely on the monochrome panel, creating series of works based on certain events and people and recurrent intellectual interests found in his own life. His wife Helen's pregnancy inspired him to create the *Annunciation* series of 1978,[23] while his interest in the primal and enduring character of Greek architecture resulted in multiple-panel constructions that echoed the post and lintel form of doorways and porches found in ancient and contemporary Greece. Marden produced at this time some of the most challenging and singular treatments of color as bearer of meaning and experience of his career.

Yet ultimately Marden found he had finally exhausted himself in making such work. He was experiencing a crisis in confidence, not only as an artist but as a person as well. In such a state, Marden was ready to abandon painting altogether until an exhibition of Japanese calligraphy in 1984 refueled his ideas about the possibilities of making art.[24] Here was an art that possessed an energy of line and motion, that appealed to Marden's pictorial sense but adhered to a set of rules that dictated the placement of intricate forms within rows and columns of austere measure.

Marden's interest in Asian calligraphy and art was thus ignited. He began a serious investigation of the history and meaning of Chinese art and of the great traditions of Chinese culture in general. Marden produced a set of etchings that were published by Peter Blum as part of a book of poetry by eighth-century Chinese poet Tu Fu, translated by American poet Kenneth Rexroth. This experience furthered Marden's thinking about calligraphic, poetic, and markmaking issues; Marden's section was titled "Etchings to Rexroth."[25] Thinking about calligraphy,

poetry, and so forth as an artist rather than a scholar, Marden had specific aims in mind aside from the mere amassing of knowledge. Marden sought out the ways in which artists had both created and thought about their work and their world.

There were, to be sure, the technical methods of creating calligraphic art and landscape painting, but Marden wished to study as well the mindset that produced calligraphy and landscape. He became seriously intrigued by the way in which artists in China lived their lives through their art, and how for them the world was a place where art *became* the world in a seamless unity of purpose, thought, and object.

From 1985 to 1990, Marden created his first paintings and works on paper influenced by this new mode of thinking. Using line as his compositional tool under the influence of the Chinese characters found in poetry, Marden tried out various pictorial possibilities that he had previously not allowed himself to entertain. These included the very simple act of placing lines on canvas that stood on their own, lines that would not be covered over by oil and wax but that would need to be brought into relation with other lines to create a composition. In two exhibitions at the Mary Boone Gallery and Mary Boone/Michael Werner Gallery, both in New York, Marden exhibited paintings in which he experimented with depth as well, something that he had not investigated in his paintings, by placing repeated triangular forms one over the other and filling areas of overlap with opaque whites. His color across the spectrum assumed new and extremely idiosyncratic tonalities, resulting in some of the most intriguing treatments of contrasting color schemes that Marden had yet risked.

The sense of freedom is everywhere apparent in Marden's painting of this time as he changes pictorial strategies at breakneck speed, here employing white washes to delineate space, there using a deep ocher (see fig. 4) or black for a background, and over here using a spectacular orange to fill in areas of densely woven lines. There is the feel in these works that Marden is finding his way within a new set of rules,[26] and that as he grew more adept at the new language a new body of work would arise of a more consistent nature. Finally in 1988–89 Marden produced a group of paintings of commanding linear structures and restricted yet lively color that closely resemble the calligraphic model as it was to be employed for the next five or so years. In these *Couplet* paintings, lines of predominantly dark color are set in a neutral background and linked with other lines to create webbed columnar structures. Marden in fact created these paintings around the idea of the two-column couplet format found in Chinese poetry. Shown at the Michael Werner Gallery in Cologne in 1989 and at the *1989 Whitney Biennial,* these paintings set the stage for what was to come next: "They were basically the same height as the *Cold Mountain*s, and they stood next to them in the studio —they were the direct forerunners."[27] From these 1988–89 paintings it was a chronologically brief but artistically intense and involved path to *Cold Mountain.*[28]

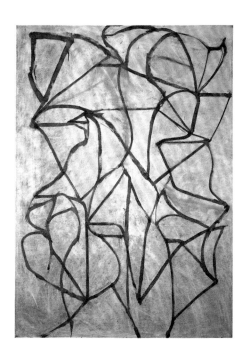

Fig. 4
4 (BONE), 1987–88.
Oil on linen, 84 × 60 in.
Helen Marden.

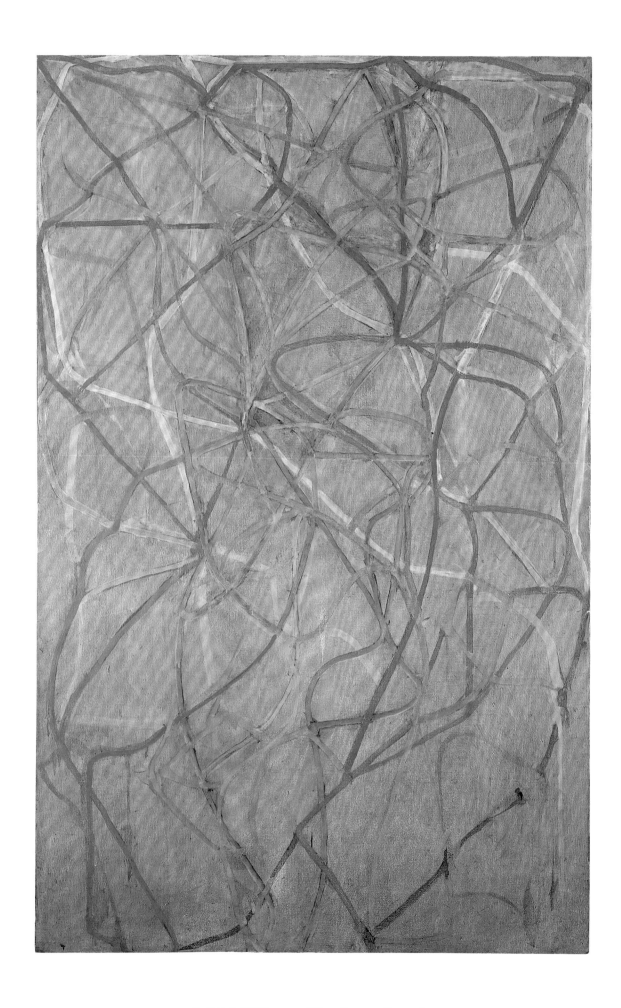

5. KALO KERI, 1990. Oil on linen, 92⅝ × 59 in.
Kunstmuseum Winterthur, anonymous gift.

Marden's *Cold Mountain* group has achieved great renown for the artist for "the clarity and grace of full mastery"[29] (in this case of the calligraphic model) that the works so obviously exhibit. Yet, typically, *Cold Mountain* was not the only concern Marden had at the time. In his three studios, Marden was at work on a number of different paintings in various stages. These were the three *Muses* paintings; the paintings *Kalo Keri* (cat. no. 5) and *Presentation* (cat. no. 6), which were shown at the 1992 *Documenta*, the once every five year international exhibition of contemporary art held in Kassel, Germany; and the four paintings that would comprise his 1993 exhibition at Matthew Marks Gallery[30] and that were included in a 1993–94 exhibition at the Kunsthalle Bern and the Vienna Secession that surveyed Marden's paintings from 1985 to 1993.[31]

Kalo Keri and *Presentation* are representative of the work Marden was producing in the 1980s (with the exception of the *Couplets*, mentioned previously as leading to *Cold Mountain*). Both paintings show that Marden's approach to background is atmospheric, implying depth and space,[32] and they also demonstrate a degree of freedom of line that will come to full fruition in the work from 1995 onward. Here there are fewer jagged forms reminiscent of calligraphy, and the color itself is rich and saturated. The ostensible subjects of the canvases have much to do with this. As Marden states, *kalo keri* means "good season"—or summer—in Greek.[33] In this high-keyed painting, a blue worthy of the intensity of the Greek sea and sky is entangled with the brilliant yellow and white of light. Here the colors enmesh in a representation of the ingredients that go into making a great, booming day in the open. For *Presentation* Marden was inspired by a reproduction of Chartres cathedral's stained glass windows that was left behind in his studio in Greece.[34] Both paintings abstractly correspond to the experience of viewing color through light—in *Kalo Keri*'s case, as sunlight travels through air on a beautiful day in the open, and in *Presentation*'s case, as sun encounters the alternately dense and airy splendor of a Gothic cathedral window.

The paintings Marden exhibited at Matthew Marks Gallery in 1993 demonstrate little of the coloristic daring of the above-mentioned paintings. In these four works, of which *Aphrodite* (fig. 5) and *Uxmal* (cat. no. 7) are shown here, Marden keeps the chromatic tone down and the emotional tenor intense yet hushed. In each of these paintings, there is an almost tentative sense of the introduction of color, one that Marden seems to be at pains to let fully loose. Yet the rigor found in *Uxmal* and *Aphrodite* is such that it seems Marden is here more interested in the intellectual project of registering a network of lines that takes *Cold Mountain* as a starting point but makes it even more complicated and evocative.

Uxmal is named for the temple site in the Yucatán that Marden and his family visited. Having started the painting before they ventured there, Marden returned to the studio with an image in his head of the vines and

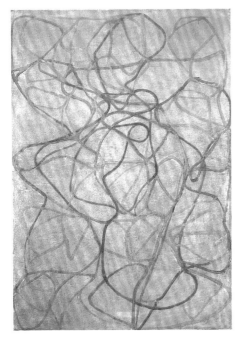

Fig. 5
APHRODITE, 1991–93.
Oil on linen, 100 × 70 in.
Cooperfund, Inc.

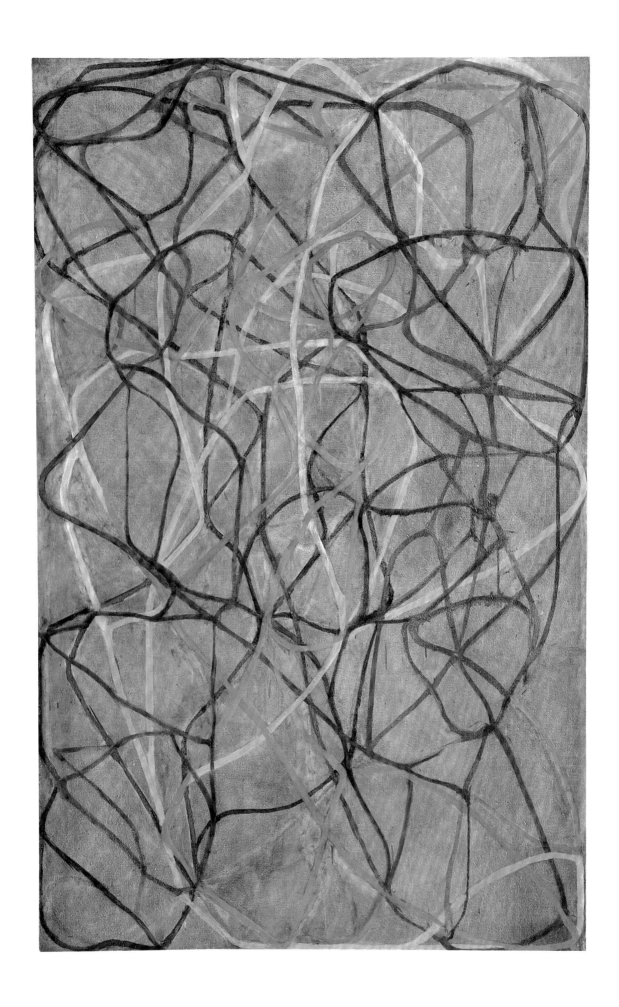

6. PRESENTATION, 1990–92. Oil on linen, 92⅝ × 59 in.
Colección Patricia Phelps de Cisneros, Caracas.

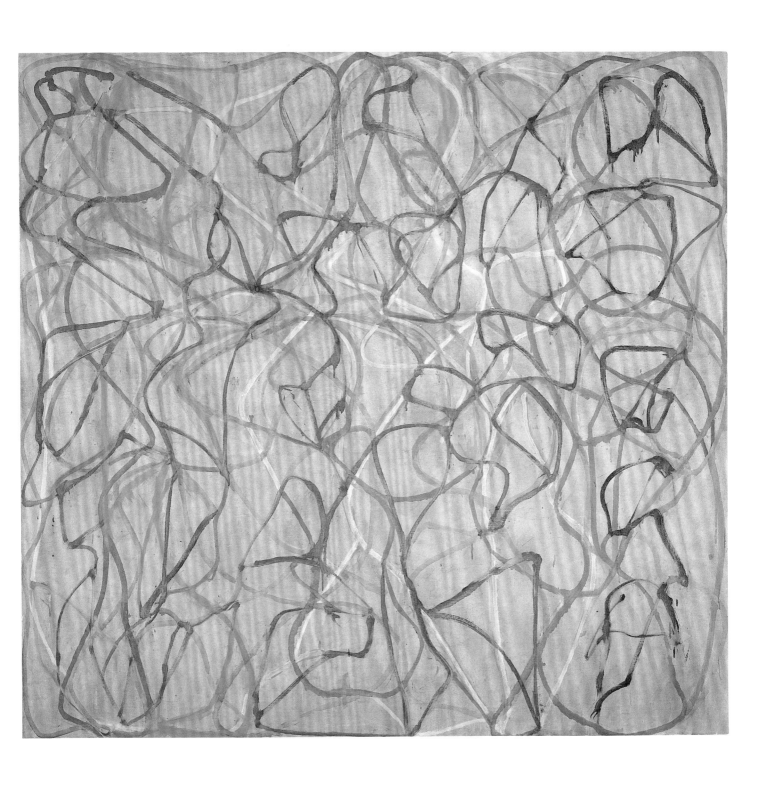

7. UXMAL, 1991–93. Oil on linen, 96 × 102 in.
The Saint Louis Art Museum, funds given by Dr. and Mrs. Alvin R. Frank,
Friends Fund, Museum Shop Fund, and Donors to the 1992 Annual Appeal.

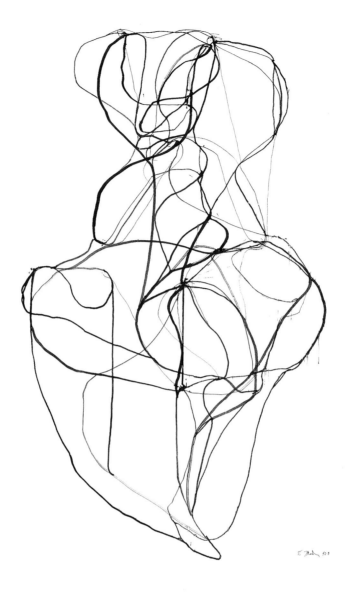

vegetation that cover the temples, and began to work from that image, creating a painting that is perhaps representationally closer to its subject than all of Marden's 1990s works. The greens, blues, grays, and whites that Marden lays down here contribute to the painting's overall somber yet dignified feel, yet the energy and motion one senses within the field hint at activity occurring just below the surface of the meshed lines.

Aphrodite is of another color scheme but is even more ascetic. Marden returns to a Greek theme of the goddess of love. While a figure is difficult to discern, one reading of the painting suggests the curve of a form bending from the top left to bottom right. Marden has expertly painted in an "aged" background akin to stone and dirt, which provides the obdurate plane upon which Marden's lines converge. Brown and yellow are the predominant colors here, but there is also a hint of green, suggesting a spark of life in this sere atmosphere. Scrubbed areas add to the patina effect of the canvas, while its relatively uncomplicated linear structure lends the work a feeling of august and simple antiquity. Such solitary goddess figures are on Marden's mind at this time, as can be seen in the

26. VENUS #2 (NEGRIL), 1992–93. Ink on paper, 40½ × 25⅞ in.
Brice Marden.

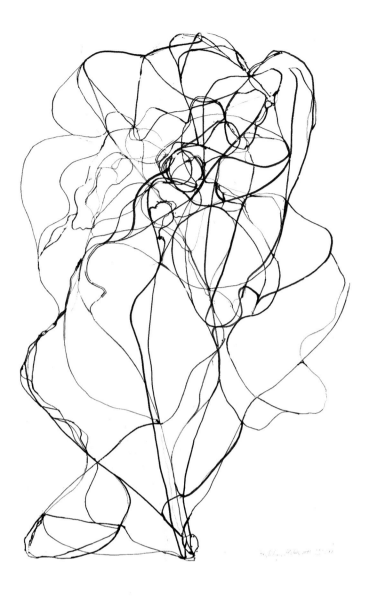

drawing *Venus #2 (Negril)* (cat. no. 26), in which Marden grants the goddess of love her Roman and later Renaissance name. As Venus, this figure appears in later etchings Marden will create in the series *After Botticelli.* In the *Venus* drawing, we see Marden referring to the more archaic type of so-called Venus figures (the Venus of Willendorf most obviously, with her enlarged midsection), which corresponds to the ostensible age of the *Aphrodite* painting Marden was interested in evoking.

A similar notion of time and antiquity is perhaps registered in the title of the drawing *Solstice* (cat. no. 27), in which Marden's line is seen at its most delicate, sweeping gently upward or cascading slowly downward, or circling in on itself in a composition akin to *Venus* but altogether more ephemeral and chimeric. As he has done throughout his career, in the 1990s Marden has kept a series of sketchbooks, in which many of his ideas concerning line and form, as seen in *Solstice,* are explored.[35]

With his 1995 paintings shown at Matthew Marks Gallery, Marden felt he had definitively broken free of the calligraphic model and tech-

27. SOLSTICE, 1993. Ink and gouache on paper, 40½ × 26 in.
Helen Marden.

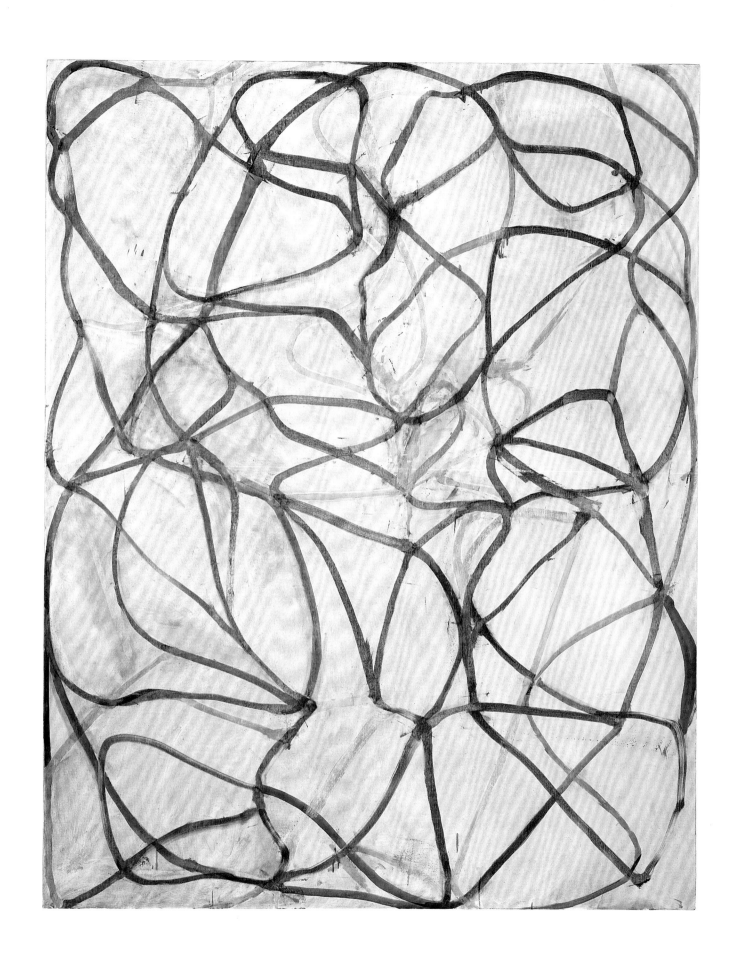

Fig. 6
CORPUS, 1991–93.
Oil on linen, 71 × 57 in.
Froehlich Collection, Stuttgart.

nique: "I didn't start off with the characters in the upper right and then work down and over as I had before with the calligraphy paintings. There aren't any columns anymore or things connecting columns. I just went into these [paintings] and started a line. It seemed much more intuitive at that point."[36] Evidence of Marden's new sense of freedom in composition can be found in the three small-scale paintings on vellum: *Small Corpus* (cat. no. 4), whose color scheme relates to both *Cold Mountain* and to a larger painting called *Corpus* (fig. 6) from the 1993–95 group; *Mask with Red* (cat. no. 12); and *Dance Glyphs* (cat. no. 18). In these dense and thickly atmospheric works, Marden exploits the organic quality of the vellum (which is lambskin stretched to create a flat surface) by laying on either quickly or more deliberately broad strokes of oil paint. Marden seems to summon antiquity with these works, as the relic nature of his marks becomes all the more pronounced and effective through such materials. In these works, along with the aptly named *Little Red Painting* (cat. no. 19), it is clear that Marden's ideas of interlocking forms and lines need not depend exclusively on the outsized, often larger than life form. *The Sisters* (cat. no. 8) is a painting that Marden feels was critical to his loosening of the calligraphic structure. It was completed in 1993, the same year he would start on the paintings that would go into his 1995 show at Matthew Marks Gallery. *The Sisters* occupies a unique place in Marden's work of the time not only for its formal breakthroughs but also for the subject: it is a representation of the relationship between Marden's two daughters.

The background of *The Sisters* is matte and flat in comparison with *Kalo Keri* and *Presentation* and the *Cold Mountain* paintings. Unlike the figures in his earlier paintings, these are brought directly to the surface; the composition fills the entire area of the canvas, and the lines are rounded and thicker. Here the figures' relationship to one another becomes more overt and forceful, the spikiness of the lines having relaxed into a flowing and more sinuous path. Marden at this point was using his whole body to paint rather than just the wrist and arm.[37] Depth is foregone here in favor of a thickly applied yellow tonality in the background that brings the figures to the front of the picture plane; indeed the notion of a background in which these lines operate becomes problematic to define and reads only as atmosphere due to the lighter hue of yellow versus that of the other pigments Marden has employed. *The Sisters* can be seen as two figures next to one another; however, the painting seems to be more about the way in which one human can be a part of and separate from another human and remain locked within each other's orbit of existence.

In a similar manner, *Chinese Dancing* (fig. 7) plays with movement and energy but in a way that recalls the ritualistic, friezelike tableau of *The Muses* and prefigures the keyed-up color and heat of the second *Muses* painting, *Study for The Muses (Hydra Version)*. In *Chinese Dancing* we see and sense the forms of a group of gesturing and moving

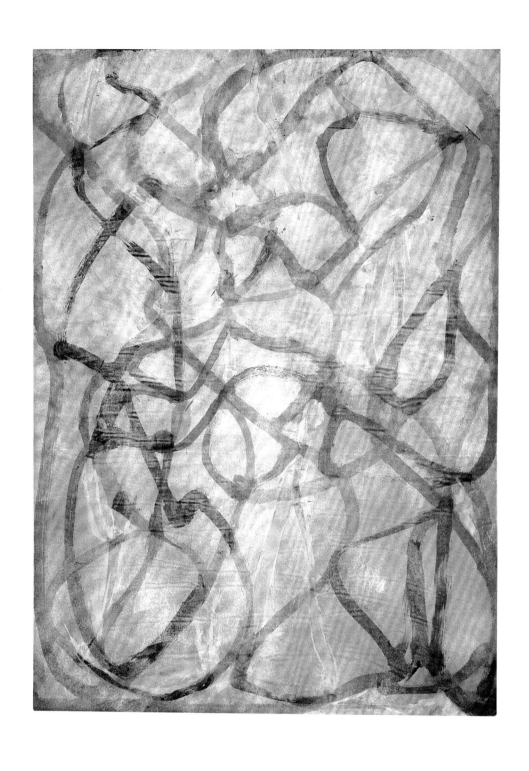

4. SMALL CORPUS, 1989–94. Oil on vellum stretched over plywood, 26½ × 19⅜ in.
Collection of Werner H. and Sarah-Ann Kramarsky.

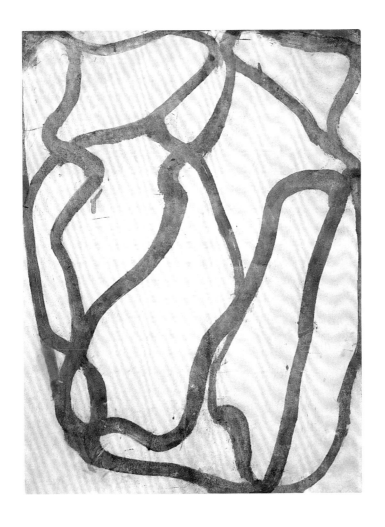

12. MASK WITH RED, 1993–94. Oil on vellum stretched over plywood, 23½ × 17⅝ in.
Brice Marden.

18. DANCE GLYPHS, 1994. Oil on vellum stretched over plywood, 12⁹⁄₁₆ × 20¹⁄₁₆ in.
Mr. and Mrs. Richard S. Fuld, Jr.

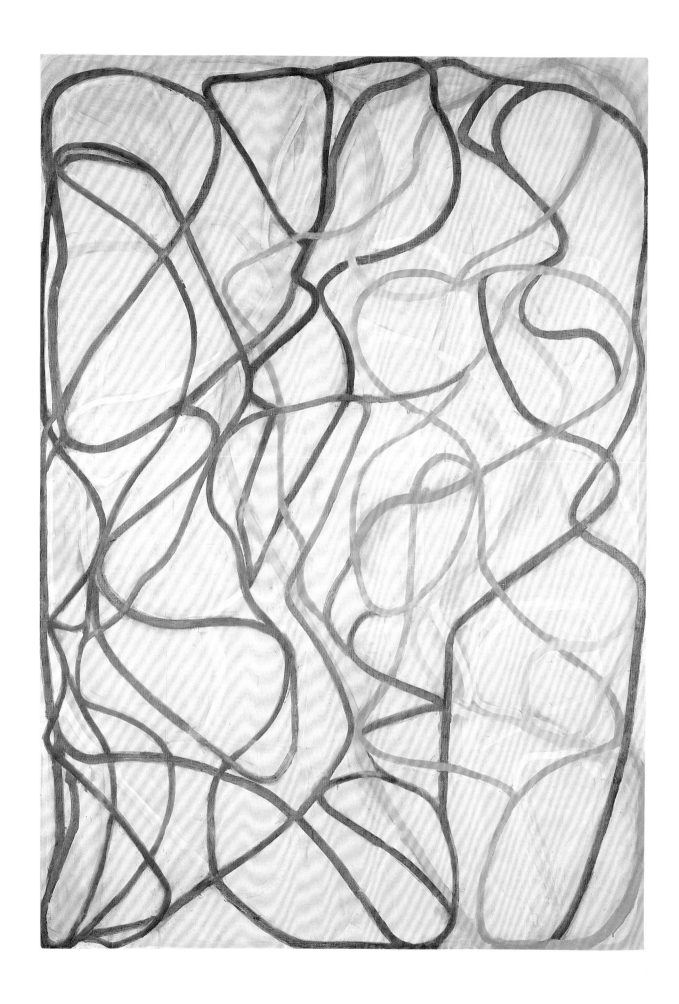

8. THE SISTERS, 1991–93. Oil on linen, 84 × 59 in.
Private collection, San Francisco.

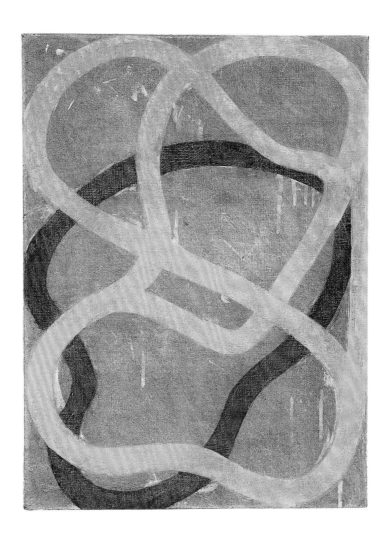

figures from left to right. Clearly Marden was exploring at this time the idea of a supersaturated color scheme of fervent intensity that led to a compositional scheme nearly unprecedented in its undulant complexity.

After *The Sisters,* and concurrent with *Chinese Dancing,* Marden set out on an ambitious cycle of nine paintings that display his newfound freedom of line and composition. These paintings appeared at once as a new treatment of Marden's vocabulary that took a wide variety of sources as subjects. In general the paintings share with *The Sisters* a greater degree of space between the networks of line. The painting *Corpus* (Latin for "body") appears to be the most closely related to the *Cold Mountain* paintings. Here Marden has set off the familiar *Cold Mountain* colors of blue, brown, and gray against a neutral putty-colored background. Yet things soon begin to change in the 1995 exhibition series (see cat. nos. 13–17) as Marden's color brightens and intensifies and his lines begin to thicken to an even greater extent. Compared with *Corpus,* Marden has created more consciously graphic paintings whose dynamic is based on curving and gliding rather than on spiking lines and forms. And Marden has gone even further with *Small Corpus,* in which the rounded lines and forms merge on the porous material of vellum to create a hazy and beautifully dense field of loamy blacks, browns, and blues. *Little Red Painting*

19. LITTLE RED PAINTING, 1994. Oil on linen, 24 × 18 in.
Collection of Susan and David Gersh.

is a concise example of Marden's language used in these paintings. Here the red and the yellow form interlock in a tight embrace, the red form remaining behind the yellow; the lines of each are of equivalent thickness, and the dual-part structure is placed right up against and along the edge of the canvas.

Marden discussed the derivation of the title for *Calcium* (cat. no. 13), another of the nine paintings series: "The atmosphere in Greece is so charged and bright because the rock in Greece has a lot of calcium in it; I was sharing a cab in Athens with some UNESCO scientists who explained that to me."[38] *Skull with Thought* (cat. no. 14) pertains to the shape of the head with the idea inside it,[39] while *Light in the Forest* (cat. no. 15) refers to Marden's walking in the woods in Pennsylvania and observing how sun falls through the trees. *The Golden Pelvic* (cat. no. 16) is a golden-toned painting with the geometrically sweeping and enveloping form of a pelvic bone delineated in the upper portion of the canvas,[40] while *Progression* (cat. no. 17) refers to a Muses-like dance being performed by the hot, energetic lines captured within the rectangle of the canvas. As evidenced by the titles and sources, Marden pursued a much more diverse set of concerns in this body of work, which is reflected in the dramatically varied look of each painting in terms of color scheme and relative density of design.

While some underlying linear structures are still visible, Marden has gone over certain lines (as he did especially memorably in *Kalo Keri* and *Presentation*) with an equally dense color to create an even greater chromatic resonance in his paintings. Previously when Marden wished to make the interior structure of his network more complex, he would go in with white and gray and connect strands of lines together and work from there. In these paintings, Marden has used a uniformly thick line that forestalls such relationships, and he has allowed the lines to touch the edge of the canvas, providing a degree of enclosure, balance—even compression. Though in places intensely vivid in color, Marden's 1993–95 paintings create the impression of a more measured level of motion and a more even field of measure.

Painted roughly concurrently with the works mentioned above but shown a year later, *Suzhou* (cat. no. 20), one of four paintings Marden exhibited in 1996 at Thomas Ammann Fine Art in Zurich, and *Suzhou, Before and After* (cat. no. 21) play with the same approach. In these paintings, the canvas is taller than it is wide and the subject is specifically Chinese. The color scheme is much cooler, and the forms seem to exist in an equilibrium to one another not found in even the 1993–95 paintings. Both paintings take nature, as it has been affected by "a city full of scholars,"[41] as their source: they are based on the rocks of fantastic shape and formation in the Ming dynasty rock gardens of Suzhou, a Chinese city west of Shanghai that Marden visited in November 1995.[42]

Marden has basically settled on the flat, thick line in the paintings he has been creating since 1995. In these works, Marden intuitively

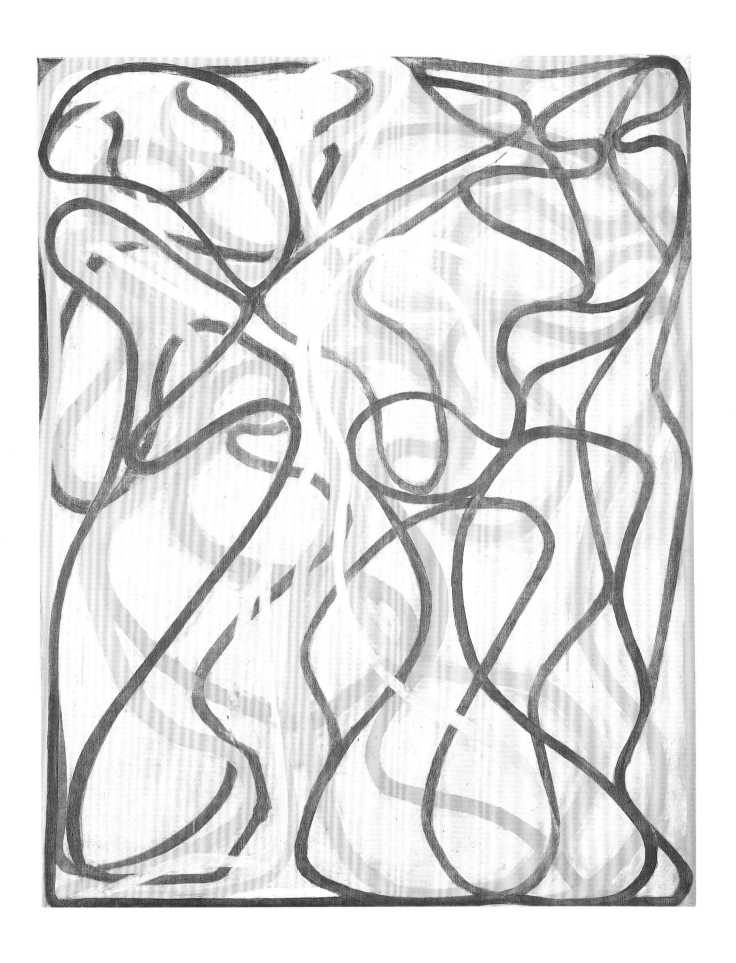

13. CALCIUM, 1993–95. Oil on linen, 71 × 57 in.
Private collection.

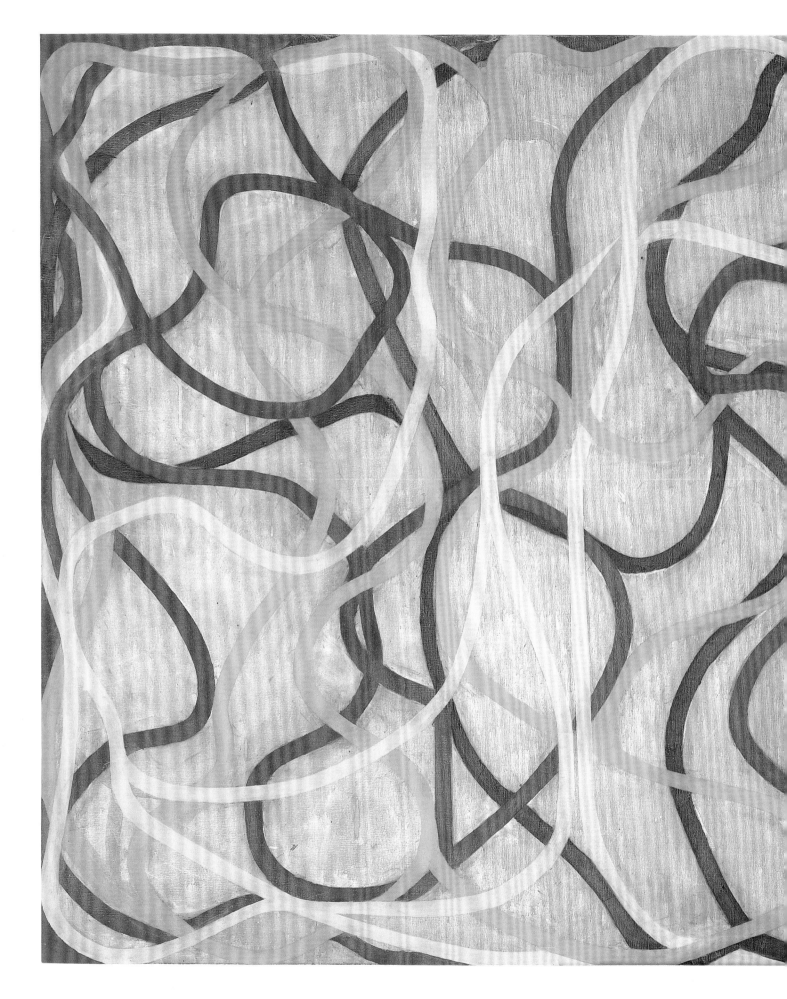

Fig. 7
CHINESE DANCING, 1993–96.
Oil on canvas, 61 × 108 in.
Collection PaineWebber Group Inc.

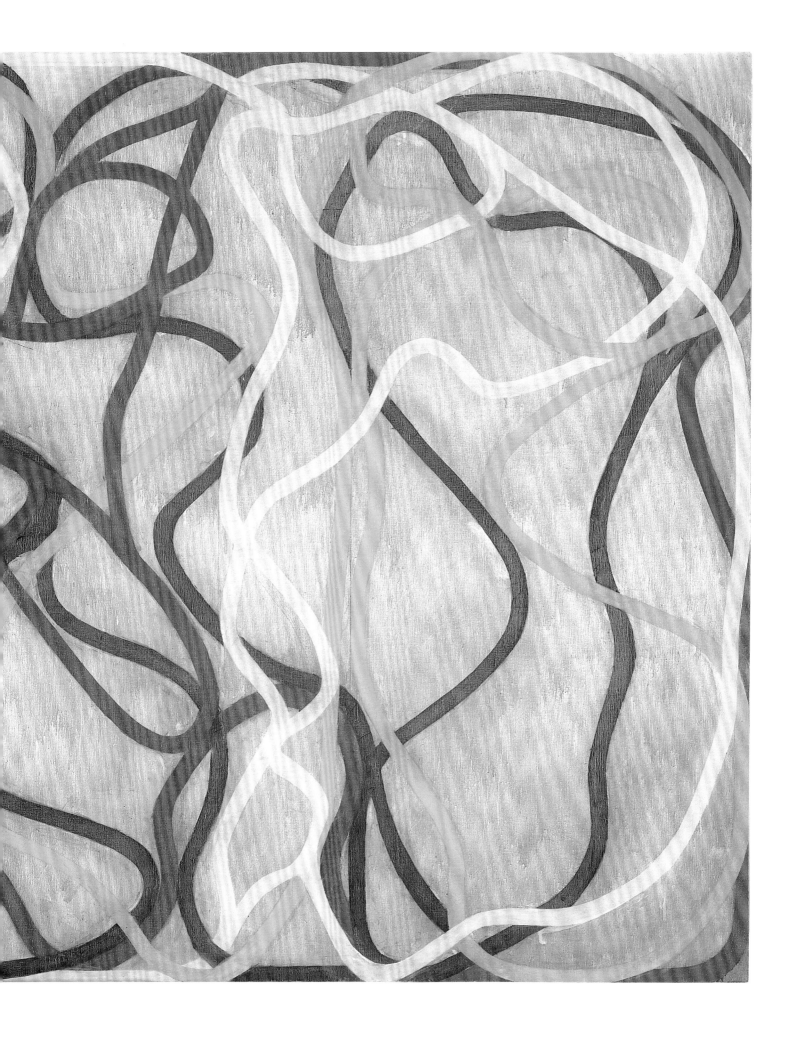

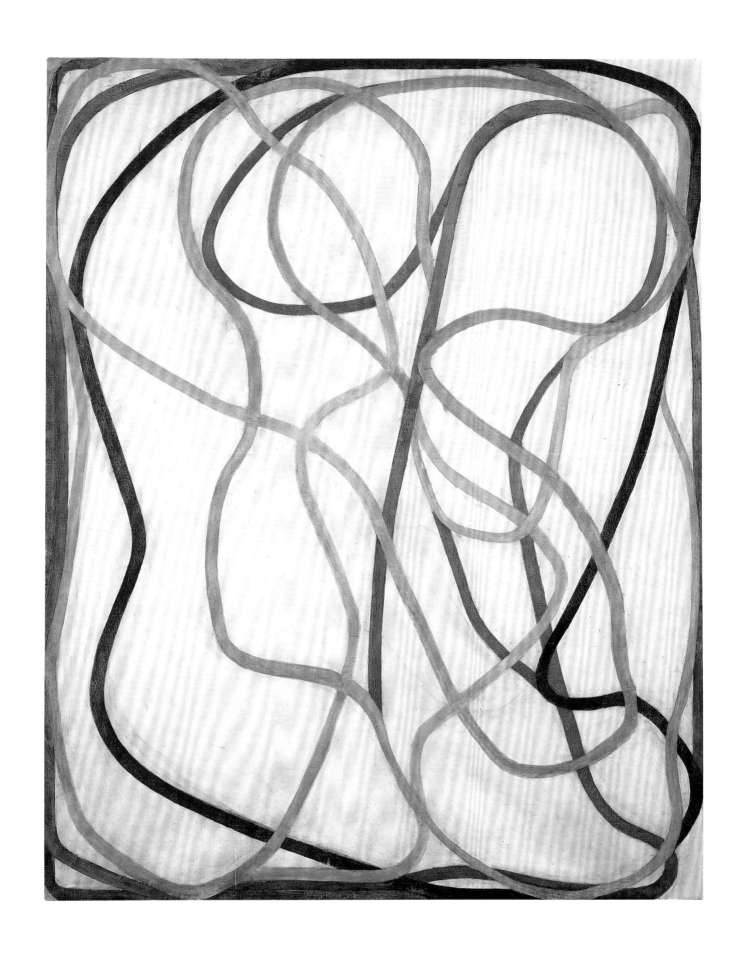

14. SKULL WITH THOUGHT, 1993–95. Oil on linen, 71 × 57 in.
Kathy and Keith Sachs.

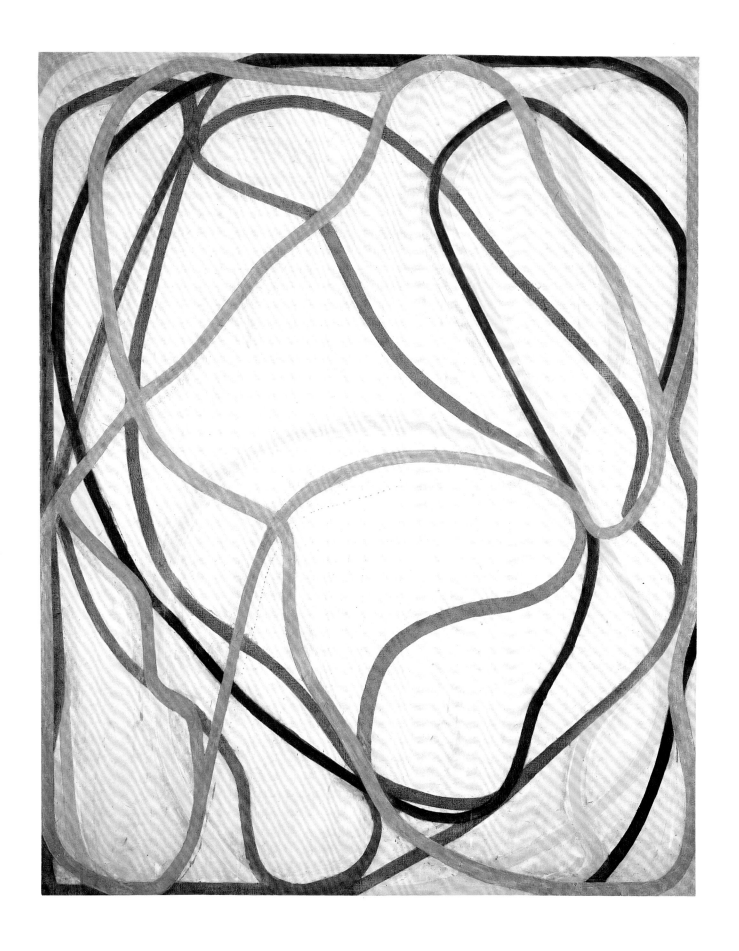

15. LIGHT IN THE FOREST, 1993–95. Oil on linen, 71 × 53 in.
Frances and John Bowes.

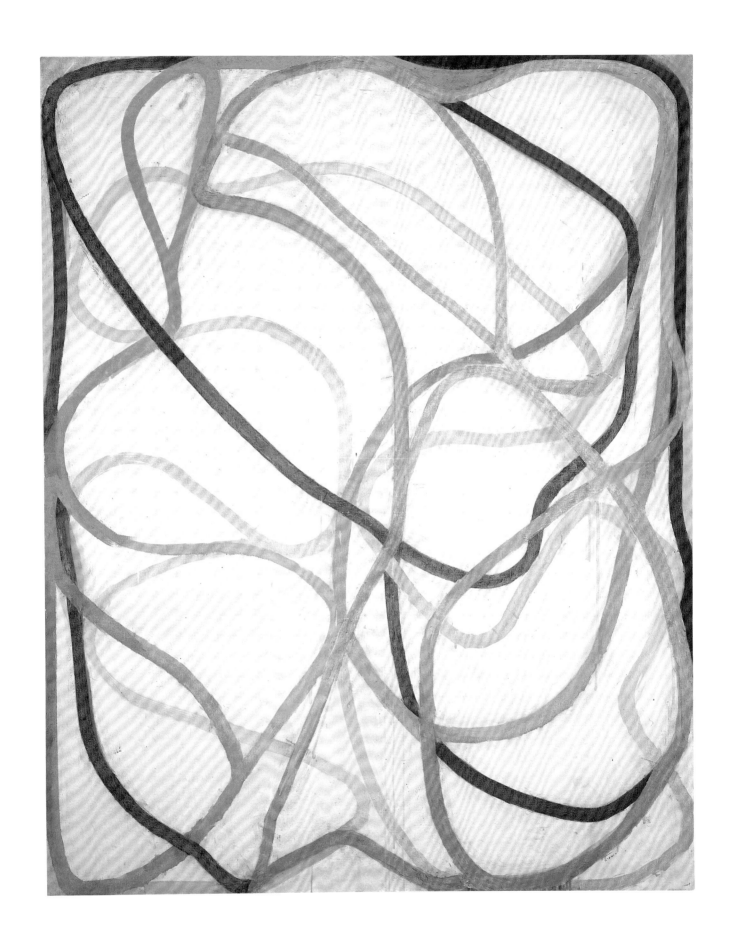

16. THE GOLDEN PELVIC, 1993–95. Oil on linen, 71 × 57 in.
Mr. and Mrs. Richard S. Fuld, Jr.

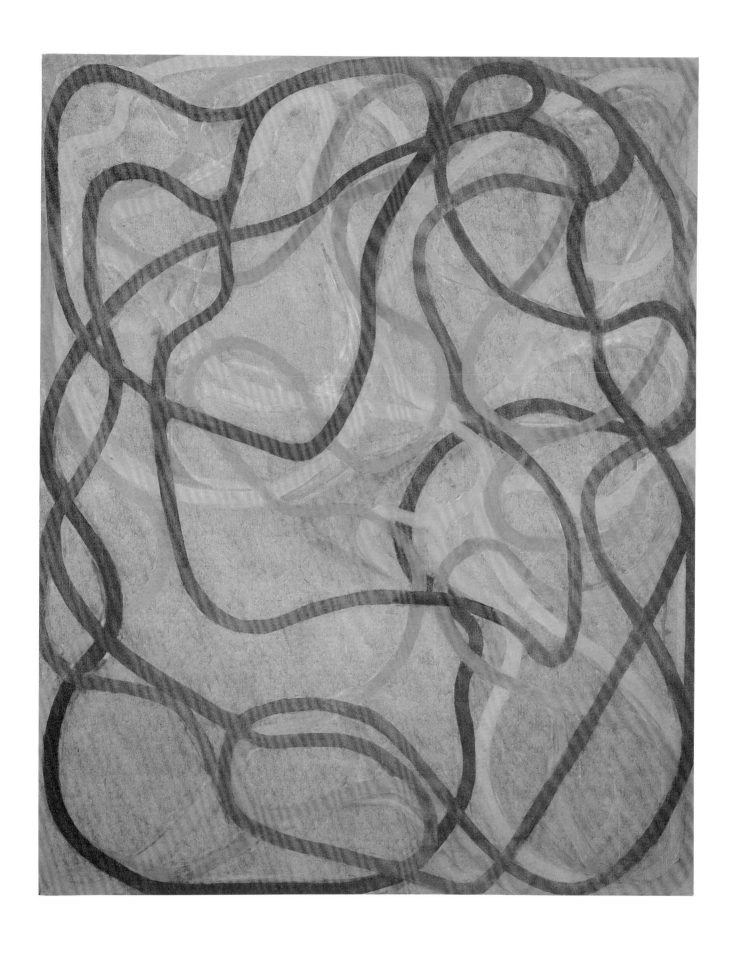

17. PROGRESSION, 1993–95. Oil on linen, 71 × 57 in.
Collection of Robert Lehrman, Washington, D.C.

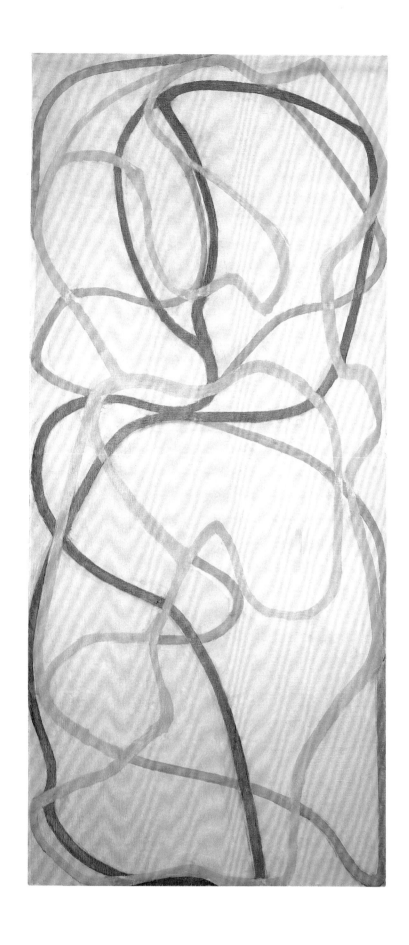

20. SUZHOU, 1995–96. Oil on linen, 72 × 32 in.
Private collection, courtesy Thomas Ammann Fine Art, Zurich.

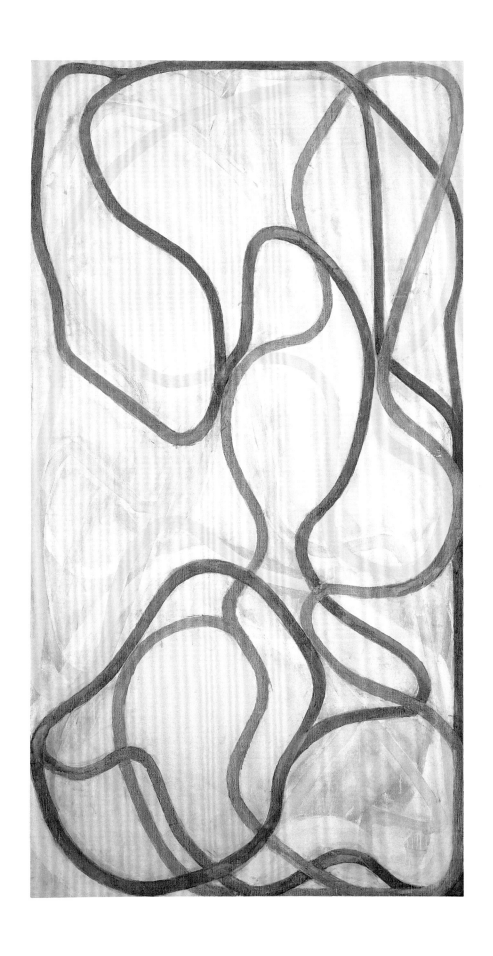

21. SUZHOU, BEFORE AND AFTER, 1995–96. Oil on linen, 73 × 39 in.
Private collection.

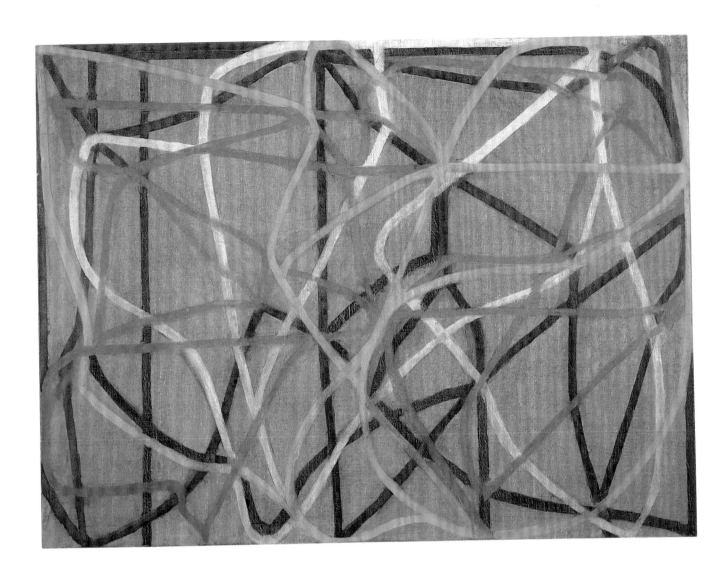

approaches the canvas and begins a line where he will, creating accord-
ing to a logic of his own devising rather than that of a system. *Prayer
Flags*, 1985/1994–96 (cat. no. 1), owes its unusual dating to the fact that in
1985 Marden began a number of what he calls "false starts." Later he be-
gan to think about the canvas again and started work on it, which led to
the present painting. In this painting, Marden brings a right-angle geom-
etry to some of his corners, and lines in some cases have straightened out
altogether. This was hinted at in *Suzhou*, which Marden was working on
at roughly the same moment, but the move to a more right-angle tone to
the work becomes explicit in *Prayer Flags*. Marden based the color
scheme on prayer flags he saw in Sri Lanka.[43] Clearly Marden's interest
in Asian art and culture has not abated as the 1990s have unfolded.

Marden's epitaph paintings of 1996–97 continue this interest in
China, and in this case the source is a memorial to the deceased. Marden
calls these paintings a "regression,"[44] not in style or thinking or quality
but because he used five Chinese stone epitaphs for his compositions
(see fig. 8). In an exhibition at Matthew Marks Gallery in 1997, Marden
showed two paintings based on the characters carved into these five

1. PRAYER FLAGS, 1985/1994–96. Oil on linen, 36 × 48 in.
Private collection.

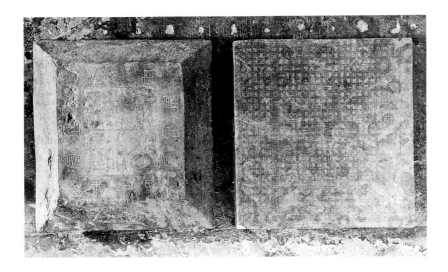

stones, along with the stones themselves. Here Marden started out with a formula but maintained his rectilinear approach. In *Epitaph Painting 2* (cat. no. 22) from 1996–97, Marden uses a basic palette of red, yellow, and two blues in an airy composition of lightly interlocking lines. Space is plentiful in this depiction, and the lines themselves, especially the red line in the upper third of the painting and the lower edge's dark gray line, create a dynamic of compression and power in a square format. Similarly in *Bear*, 1997 (cat. no. 23), Marden continues in this vein. In this case, he was impressed with the physical power of a bear he witnessed outside his studio in the woods of Pennsylvania. Marden quietly picked up his dog and brought him inside so the dog would not attack the physically superior bear; he translated this encounter into three paintings.

THE MUSES

Like China, Greece has continued to occupy Marden in the 1990s: the Muses have remained with Marden throughout the last ten years. A glance at his two latest *Muses* paintings provides a summary of the artist's concerns of the last decade and encapsulates many of the issues that have come to the fore in Marden's mind about making art for himself and within his society.

Marden began work on *Study for The Muses (Hydra Version)* and *Study for The Muses (Eaglesmere Version)* at the same time he was working on the larger *Muses* of 1991–93. *Study for The Muses (Hydra Version)* could not be more different in feel than the first *Muses* painting. Here Marden has employed the wider, flatter, and more opaque line that characterizes his 1993–95 paintings, and he has used a primary color–based palette that rings with sensuality and warmth. "It's kind of like some of the color I was using in the panel paintings, where I was really pushing the intensity of the color. When you're in such a strong light as Greece, you have to make your color stand up to that. It's a challenge to confront the light there."[45] Marden revised this painting extensively, as can be seen in the faint background structure that he effaced with a dull white.

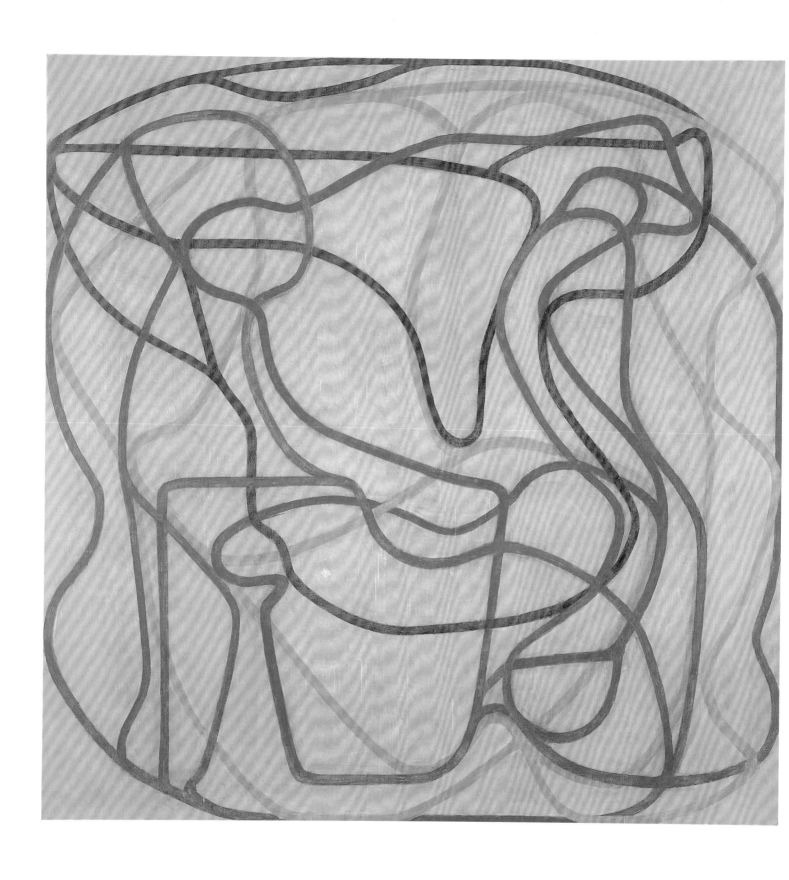

22. EPITAPH PAINTING 2, 1996–97. Oil on linen, 94 × 93½ in.
Private collection, New York.

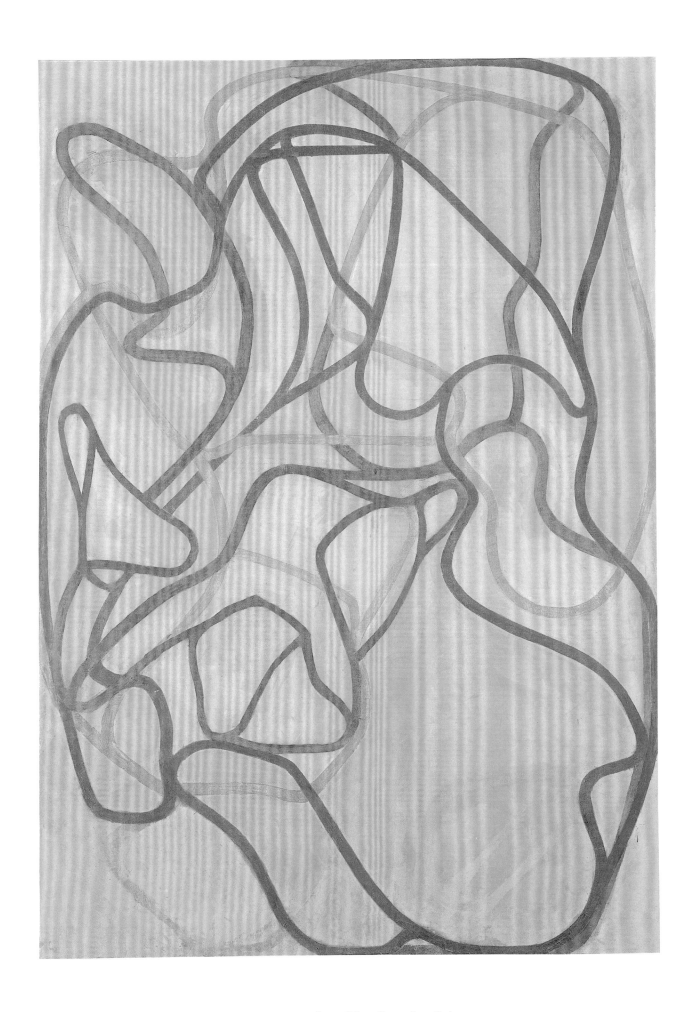

23. BEAR, 1996–97. Oil on linen, 84 × 60 in.
David Pincus.

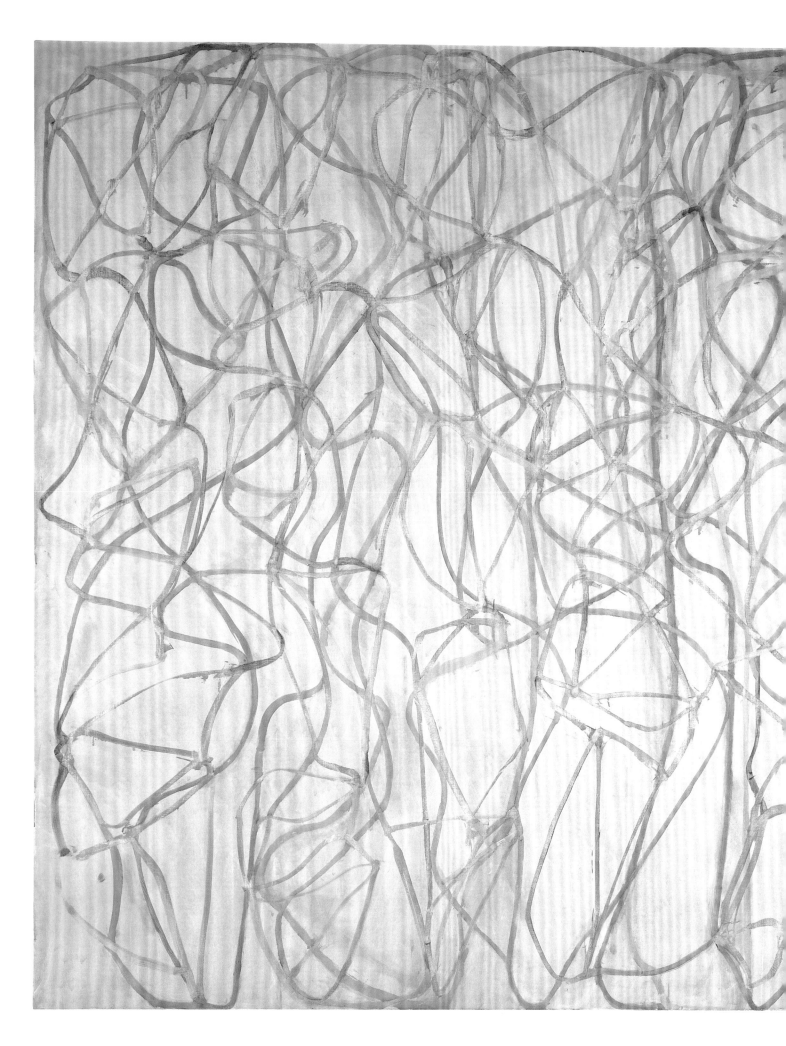

9. THE MUSES, 1991–93. Oil on linen, 108 × 180 in.
Daros Collection, Switzerland.

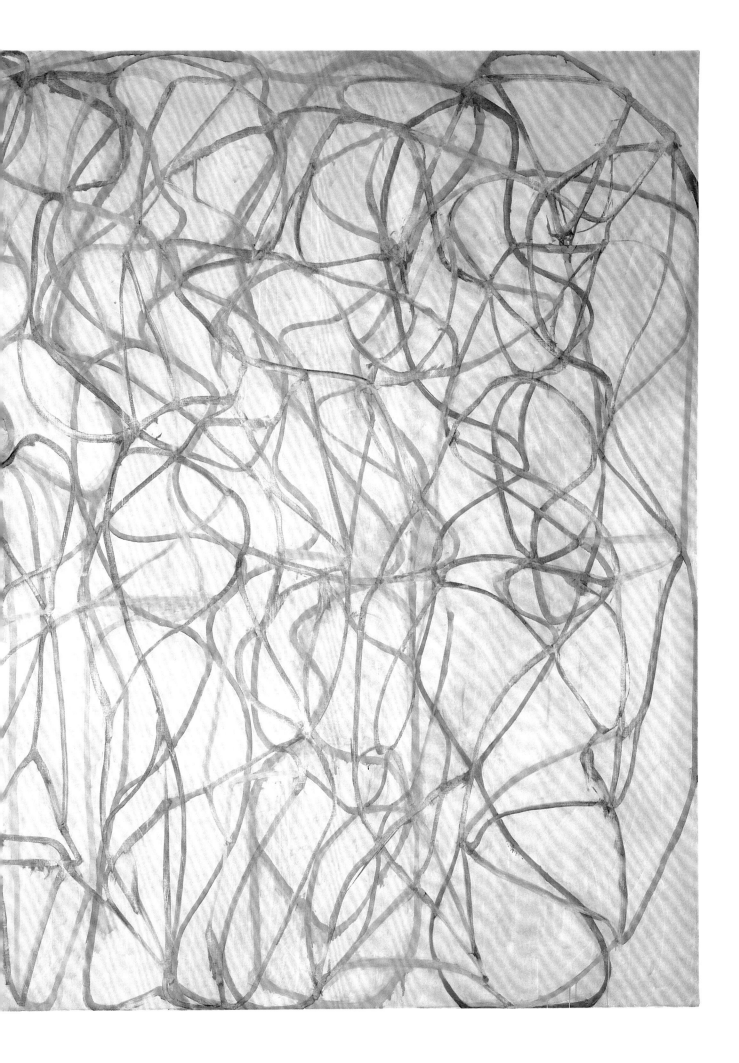

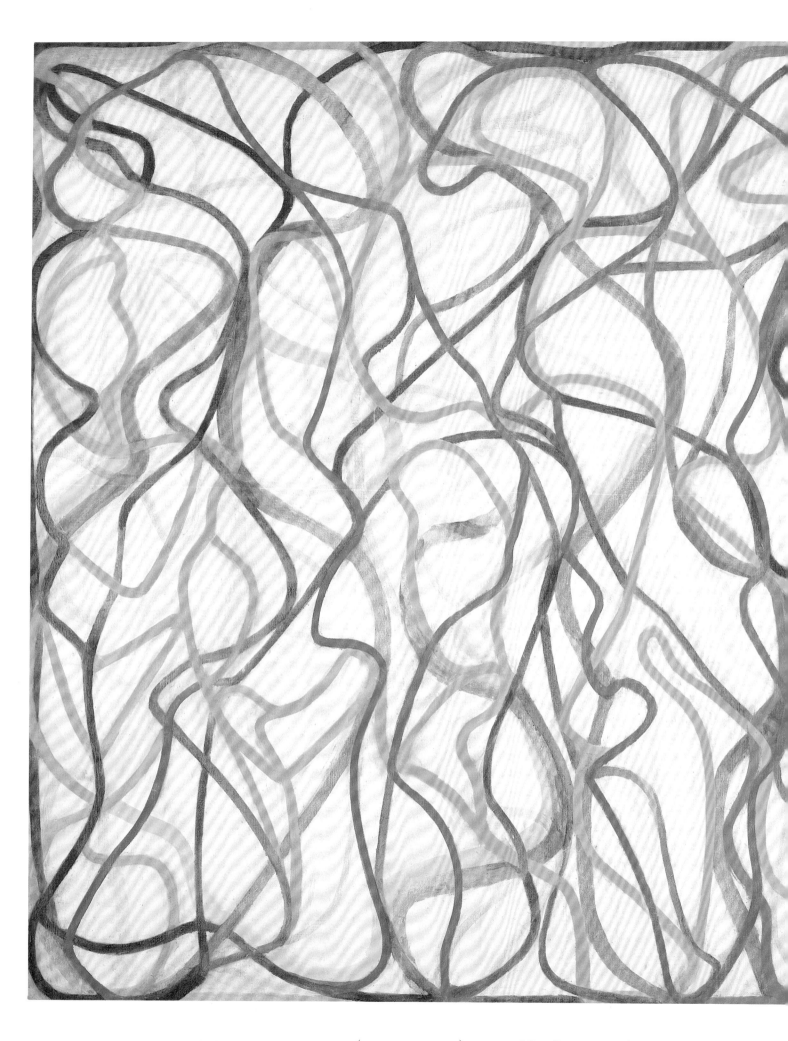

10. STUDY FOR THE MUSES (HYDRA VERSION), 1991–97. Oil on linen, 83 × 135 in. Private collection.

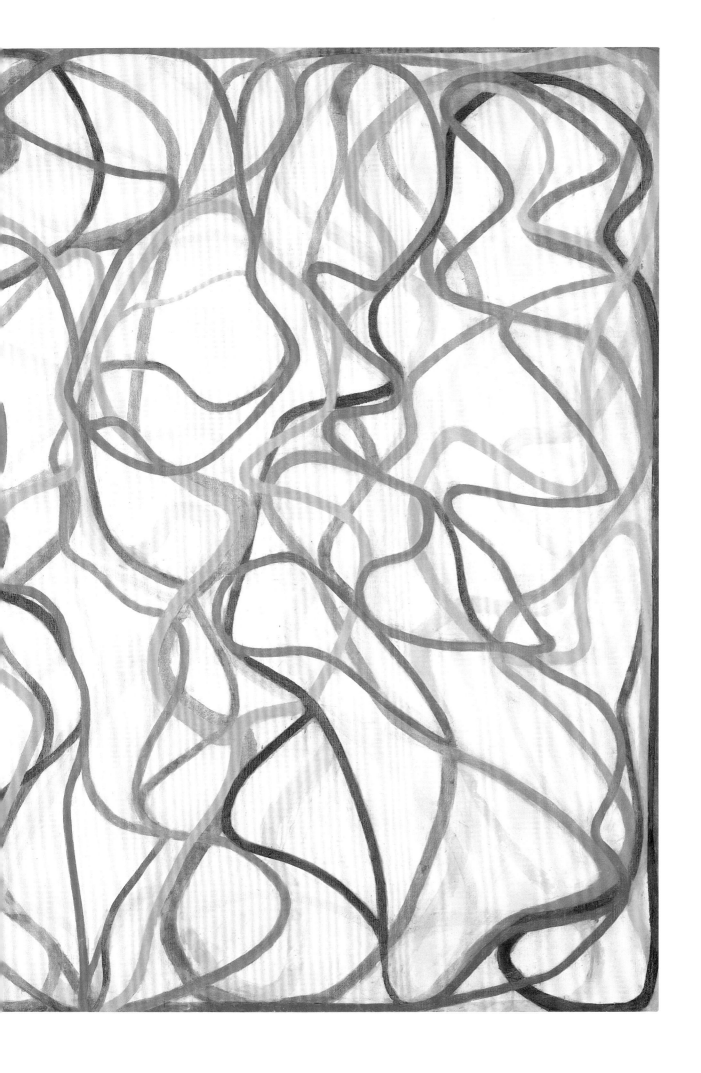

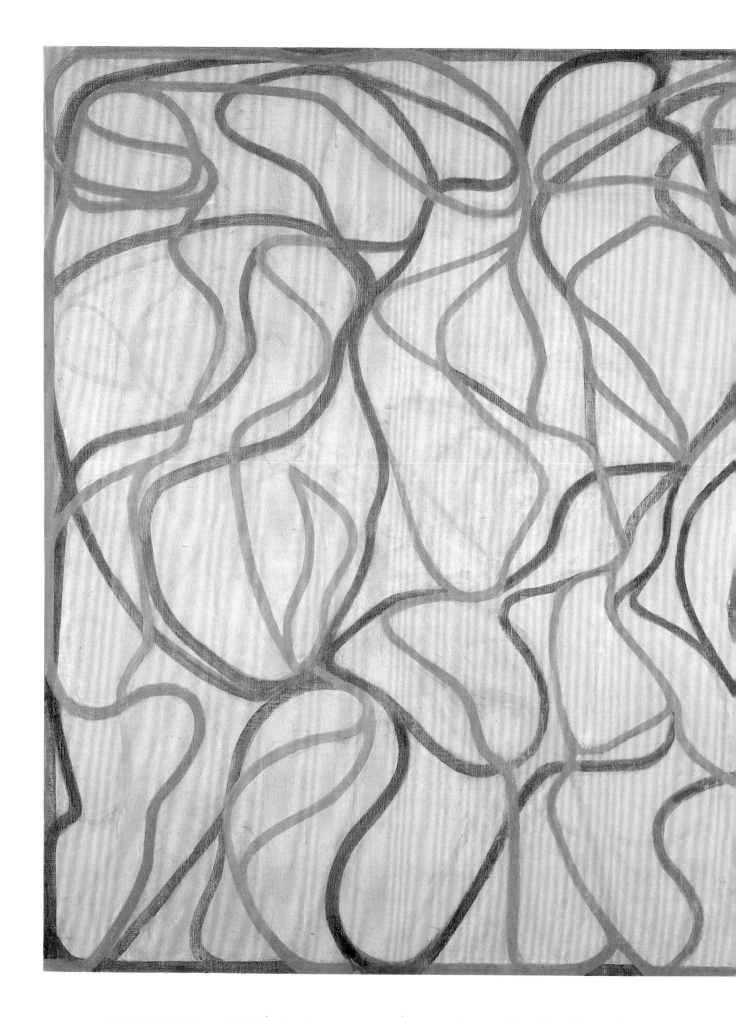

11. STUDY FOR THE MUSES (EAGLESMERE VERSION), 1991–94/1997–99. Oil on linen, 83 × 135 in.
Brice Marden. As of October 1998.

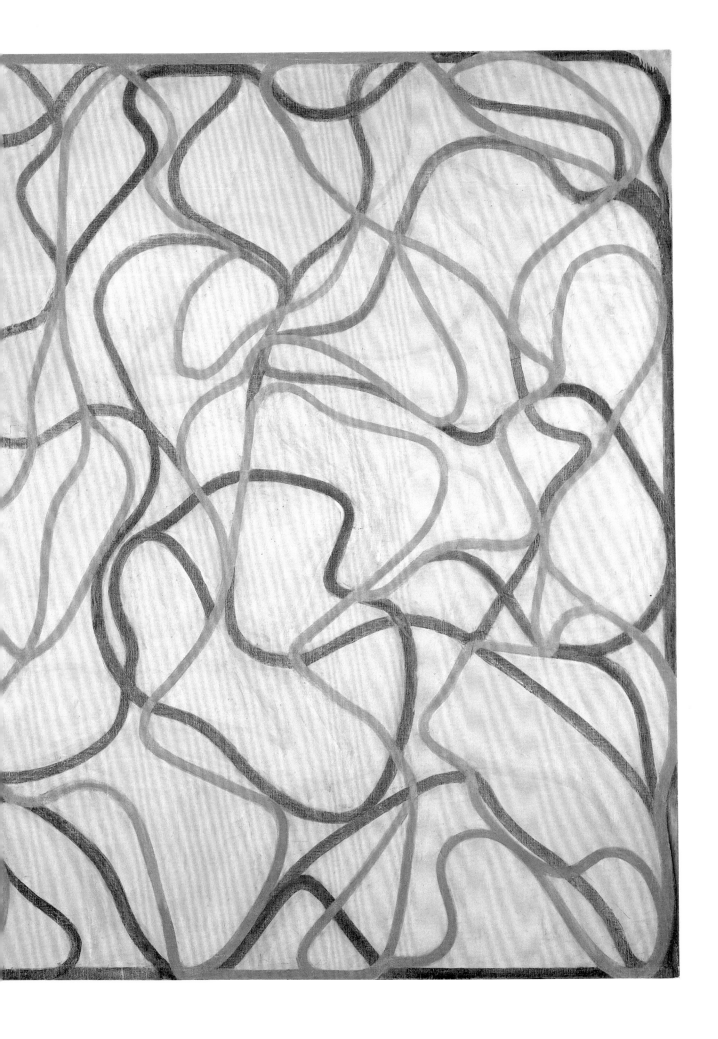

Marden did so to simplify the structure of the composition. In an earlier version of the work, a much busier pattern is seen roiling over the surface of the canvas, but Marden felt there was too much activity going on inside it to give the painting its proper focus and effect. In contrast to the earlier *Muses,* the work is still energetic yet marked by a steady and regular current of energy.

Study for The Muses (Eaglesmere Version) is, in its present state, another painting altogether different from its predecessors. The painting resulted from Marden's reworking of *February in Hydra,* as has been mentioned. In conversation Marden remarks about this unfinished *Muses* painting: "In the center there turned out to be a head; it's a round thing but it was reading too much like a head so I had to take it out. It was just too literal and distracting. Then I took out the green running down the side—just some things like that that didn't fit quite right. All the colors I'm using are premixed so I can paint wherever I am, but I'm working on [the painting] now in Eaglesmere. I'm repainting all the shapes, but there's still some of the old *pentimenti,* and I'm trying to fill in the shapes somehow. There are parts that are awkward. I'm also building up the surface, really pressing the paint with a knife into the canvas so it's thicker; there's a real surface and texture there. Then I'll go in and probably rework the entire thing."[46] Using the basic template of lines converging, splitting off, and rejoining, Marden keys his palette in a quieter register to echo the color and feel of the cool mountain farmland from which these *Muses* have arisen. The same can be said of the pitch of three drawings done in a mountain area, *Eaglesmere Set, 4* and *Green Eaglesmere Set, 2* and *3* (cat. nos. 28, 29, and 30), in which Marden uses a surprisingly complex range of greens (including yellow in some parts) that connote the same Pennsylvania locale as will the finished Pennsylvania *Muses.*

When compared with the early *Muses* painting, these two later *Muses* paintings, which have occupied Marden in the 1990s, chart the changes that have occurred in Marden's work of the last decade. Marden has gone back to the Muses again and again for the formal possibilities they afford—a grand group of figures caught up in motion—and for the profound theme that represents the aesthetic aspirations of the human mind.

If *Cold Mountain* in effect ends the 1980s, encapsulating in a brilliant series of works the ideas Marden was contending with since 1985, the *Muses* taken as a whole are the representative cycle for the 1990s. Marden has said about *Study for The Muses (Hydra Version),* "If it ever gets done, this painting will explain to me what I've been doing the past decade."[47] They move from the ghostly and reticent figures of fugitive imagination to the hot-blooded and declarative figures of abandon to the cool and stately rhythmic figures of calm and repose. A perceptive writer commenting on Marden's paintings of the early 1990s recognized the psychological power behind the artist's line at the time, saying, "Marden's line seems utterly of the moment, in part because of its apparent tenuousness, hesitancy, continual dissolution" and that Marden's line "is a vehicle . . .

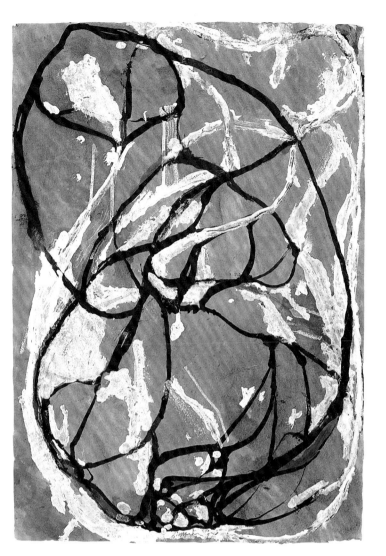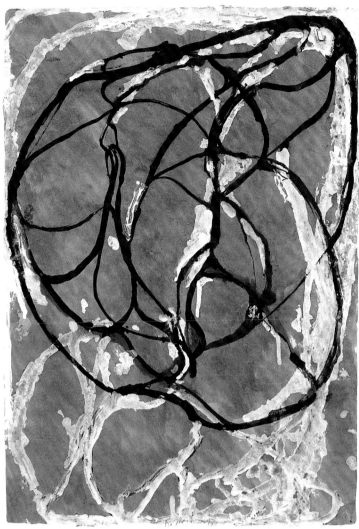

for the explicitly hindered gesture."[48] If in fact Marden's earlier paintings of the 1990s exhibit such a recessive character, works of the later 1990s do just the opposite: they are full-bodied, head-on, and assertive.

Marden's journey through the 1990s has produced some of the most compelling painting of our era. His latest work of the 1990s, based on the intricacies of line and color, connects to the work with which Marden first made his name in the 1960s, based on form and color. A continuity exists in Marden's work that demands that the senses of the viewer be at full receptive pitch. We must attune ourselves to the experience of standing on our own with the work and examining the effect it has on us as viewers. An exhibition of Marden's work provides the chance to assess not only the formal evolutions that Marden has undertaken but the changes in feeling that his work produces as well. Even to those unfamiliar with Marden's history, sources, and influences, the difference in feeling between the three *Muses* paintings is more than obvious. Activity

29. GREEN EAGLESMERE SET, 2, 1997. Colored ink wash, shellac ink on paper, and gouache, 17⅝ × 12½ in. Dr. and Mrs. Paul Sternberg, Glencoe, Illinois.

30. GREEN EAGLESMERE SET, 3, 1997. Colored ink wash, shellac ink on paper, and gouache, 17⅝ × 12½ in. Mr. and Mrs. Stanley R. Gumberg, Pittsburgh.

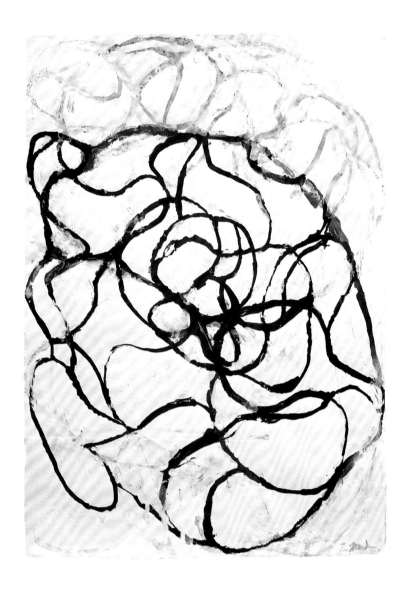

subdued, or declarative, or measured is at the heart of these paintings, where the mind goes from the shadows into light into serenity.

Marden worries about the notion of beauty in relation to his own work, stating that "the idea of beauty can be offensive. . . . Maybe beauty is too easy. It doesn't deal with issues; political issues or social issues. But an issue that it does deal with is harmony."[49] Harmony seems in short supply these days. Is it naive to look to the experience of art to provide an example of it? Is it foolish, even morally irresponsible, to be seduced by a painting, to have one's senses frankly and joyfully engaged with the laserlike efficiency of which Marden's art is capable? Do such thoughts occur with other artists' work, or do we reserve them for our contemporaries alone?

In Hesiod's *Theogony,* a work in which the ancient Greek poet of the eighth or seventh century B.C. calls upon the nine Muses for inspiration, we recognize the "later version" of the Muses that Marden spoke of in connection with his reading of Graves. In the opening lines of the *Theogony,* Hesiod introduces his Muses as follows:

28. EAGLESMERE SET, 4, 1996–97. Ink and gouache on paper, 17¹⁵⁄₁₆ × 12⅝ in.
Private collection.

I begin my song with the Helikonian Muses;
they have made Helikon, the great god-haunted mountain,
their domain;
their soft feet move in the dance that rings
the violet-dark spring and the altar of mighty Zeus.
They bathe their lithe bodies in the water of Permessos
or of Hippokrene or of god-haunted Olmeios.
On Helikon's peak they join hands in lovely dances
and their pounding feet awaken desire.
From there they set out and, veiled in mist,
glide through the night and raise enchanting voices
to exalt aegis-bearing Zeus and queenly Hera.[50]

In a notebook he kept while making a landmark series of five paintings based on what it feels like to be in Greece, eventually called *The Grove Group,* Brice Marden wrote about what it sometimes feels like to be a painter in New York.

I've heard it said,
painting is dead.
Too much mouth
not enough eyes.*

* Chant often uttered by artists on completion of a new piece. I personally heard it uttered on Broome St., West Broadway, Park Ave. South and 17th St., even as far south as Chambers Street. It is accompanied by a gleeful soft step dance too complicated to define because it means defining joy.[51]

1. Yve-Alain Bois, "Marden's Doubt," in *Brice Marden: Paintings 1985–1993* (Bern: Kunsthalle Bern and Wiener Secession, 1993), 43.

2. Brice Marden, conversation with author, July 6, 1998.

3. Bois in "Marden's Doubt" bases his extensive essay on his reading of Marden's late 1980s and early 1990s paintings as lungs, leading to a discussion of Cézanne, Pollock, and Johns as important influences on Marden's work.

4. At the end of Bois's essay "Marden's Doubt," he addresses the way Marden is never entirely sure that he is creating a valid art, either for himself or for his times. Yet as Bois notes in closing: "[T]he strength of a faith can only be measured by the doubts that torment it." Bois, "Marden's Doubt," 67.

5. *Brice Marden: Cold Mountain* was organized by Dia Center for the Arts, New York; Walker Art Center, Minneapolis; and The Menil Collection, Houston. The accompanying catalogue is a model of precision and research. See Brenda Richardson, *Brice Marden: Cold Mountain* (Houston: Houston Fine Art Press, 1992). *Brice Marden: Cold Mountain* was on view at the Dia Center from October 1991 to May 1992 and traveled to the Walker, the Menil, Museo Nacional Reina Sofía, Madrid, and the Städtisches Kunstmuseum Bonn through June 1993.

6. Brice Marden states: "Pollock was the only Western artist of this century—well Cézanne and Pollock." Pat Steir, "Brice Marden: An Interview," in *Brice Marden: Recent Drawings and Etchings* (New York: Matthew Marks Gallery, 1991), unpaginated. See also Richardson, *Brice Marden: Cold Mountain,* for her invaluable transcription of Marden's talk on Pollock given at The Museum of Modern Art, New York, on November 16, 1989. See also Bois, "Marden's Doubt," 63: "[Marden] came back to [Cézanne] . . . via Pollock."

7. Richardson's catalogue essay "The Way to Cold Mountain" gives an exhaustive account of Marden and his life and art leading up to *Cold Mountain.* Richardson, *Brice Marden: Cold Mountain.*

8. Steir, "Brice Marden: An Interview," unpaginated.

9. Marden, conversation with author, July 6, 1998.

10. According to *Who's Who in Classical Mythology* (Oxford University Press, 1993), 225, the Muses are "Calliope 'fair voice' (epic poetry), Clio 'renown' (history), Euterpe 'gladness' (flute-playing), Terpsichore 'joy in the dance' (lyric poetry or dance), Erato 'lovely' (lyric poetry or songs), Melpomene 'singing' (tragedy), Thalia 'abundance, good cheer' (comedy), Polymnia 'many songs' (mime), and Urania 'heavenly' (astronomy)." Henry James's *The Tragic Muse* is an early modern treatment of the "sacred fire" (James's term) that the Muses are meant to inspire.

11. Marden, conversation with author, July 6, 1998. See Robert Graves, *The Greek Myths,* rev. ed., vol. 1 (Harmondsworth, England, and Baltimore, Md.: Penguin Books, 1960).

12. Richardson mentions that Marden began this painting (as a tribute to his father) in Eaglesmere, Pennsylvania. Richardson, *Brice Marden: Cold Mountain,* 53–54. Marden confirmed that this fifteen-foot-long work is indeed *The Muses,* which he moved to New York in 1993 after finishing it in Pennsylvania. Marden, conversation with author, July 6, 1998.

13. The two "smaller" Muses paintings were both begun in Greece at the same time Marden was beginning work on *The Muses.* Marden used these two paintings as sites of experimentation and extended thinking throughout the 1990s, making them "studies" somewhat after the fact.

14. Bois, "Marden's Doubt," 47.

15. Ibid.

16. Ibid., 43.

17. See *Brice Marden: The Grove Group* (New York: Gagosian Gallery, 1991).

18. Brice Marden, conversation with author, October 18, 1996.

19. "The militancy of Marden's reductive abstraction relates his work to the Minimalism of the Sixties, but his insistence upon being painterly and his controlled but open willingness to risk the arbitrariness of subjectivity set his art apart from most of his peers." Klaus Kertess, "Plane Image: The Painting and Drawings of Brice Marden," in *Brice Marden: Paintings and Drawings* (New York: Harry N. Abrams, 1992), 19. This monograph is a definitive and beautiful summary of Marden's career.

20. Brice Marden, "Brice Marden: Selected Statements, Notes and Interviews," in *Brice Marden: Paintings, Drawings and Prints 1975–80* (London: Whitechapel Art Gallery, 1981), 54.

21. "The painting *Nebraska* is, of course, not a painting of Nebraska's landscape so much as it is a search to retrieve and make concrete the memory of the experience of the (Nebraska) landscape." Kertess, "Plane Image," 16.

22. For an extensive story on the Marden family house and studio on Hydra and on Marden's artistic changes, see James Reginato, "Marden's Retreat," *W,* November 1997.

23. A decade previously, Marden represented his wife, Helen, in *The Back Series.* In these paintings, Marden created an abstract notion of Helen's naked back. Marden said she had (metaphorically) turned her back on him at the time. The Dallas Museum of Art's painting *No Test,* 1968–70, is related to *The Back Series* in

that Marden used the canvas first as a study and soon realized it was a painting in its own right—hence the title. Marden, conversation with author, October 18, 1996.

24. "Brice Marden was first struck by the beauty and authority of calligraphy in late 1984, when he saw the exhibition 'Masters of Japanese Calligraphy' at New York's Asia Society and Japan House galleries." Helen Marden suggested Marden see the exhibition. Richardson, *Brice Marden: Cold Mountain,* 49.

25. Tu Fu, *Thirty-six Poems,* trans. Kenneth Rexroth, with etchings by Brice Marden (New York: Peter Blum Edition, 1987).

26. Bois uses the term "transitional" to describe the quality of a few paintings around 1987. Bois, "Marden's Doubt," 31. Marden has described some of these works as "false starts" but remains enthusiastic about others. Marden, conversation with author, July 6, 1998.

27. Marden, conversation with author, July 6, 1998.

28. The chapter "A Better Painting" is a detailed account of the chronology of Marden's paintings at this time, including the *Cold Mountain* series. Richardson, *Brice Marden: Cold Mountain,* 53–72.

29. Kertess, "Plane Image," 47.

30. See *Brice Marden: Paintings, Drawings, Etchings* (New York: Matthew Marks Gallery, 1993).

31. See *Brice Marden: Paintings 1985–1993,* which contains Bois's essay "Marden's Doubt," referred to often in the present essay.

32. Bois's argument about the layering Marden found in Cézanne and Pollock that he then translated into his own work is connected to these two paintings; Bois says *Kalo Keri* is the painting "that prompted the lung metaphor." Bois, "Marden's Doubt," 47.

33. Marden, conversation with author, September 3, 1998.

34. Bois, "Marden's Doubt," 41.

35. See *Brice Marden: Work Books 1964–1995* (Düsseldorf: Richter Verlag, 1997) for a tremendously effective presentation in facsimile form of many of what Marden calls his "work books," containing scores of drawings.

36. Marden, conversation with author, July 6, 1998.

37. Ibid.

38. Ibid.

39. This can also be seen as a reference to another of Marden's 1990 paintings. "The title of *Picasso's Skull* comes from the fact that the image of Picasso's alledged [*sic*] last self-portrait,

combined with that of one of his skull sculptures, 'appeared' at some point of the process in the tangles of this painting." Bois, "Marden's Doubt," note 17.

40. Marden, conversation with author, July 6, 1998.

41. Brice Marden, conversation with author, October 8, 1998.

42. Marden, conversation with author, July 6, 1998.

43. Ibid.

44. Brice Marden, conversation with author, June 19, 1998.

45. Ibid.

46. Marden, conversation with author, July 6, 1998.

47. Reginato, "Marden's Retreat," 248–50.

48. Madeleine Grynsztejn, *About Place: Recent Art of the Americas* (Chicago: The Art Institute of Chicago, 1995), 36.

49. Steir, "Brice Marden: An Interview," unpaginated.

50. Apostolos N. Athanassakis, trans., *Hesiod: Theogony, Works and Days, Shield* (Baltimore and London: The Johns Hopkins University Press, 1983), 13, lines 1–11. I thank Matthew Marks for this citation and for the Hesiod volume.

51. Transcription of a sheet from the unpaginated "Grove Group Notebook" that was reprinted in *Brice Marden: The Grove Group,* 21.

Biography

BRICE MARDEN was born in 1938 in Bronxville, New York, and grew up in the nearby town of Briarcliff Manor. Marden attended Florida Southern College; Boston University School of Fine and Applied Arts, where he earned his bachelor of fine arts degree in 1961; and Yale University, where he earned a master of fine arts degree in 1963. Marden is considered one of today's most important artists. He has continually engaged the tenets and practices of abstraction, first through his series of monochrome panels and drawings from the 1960s, 1970s, and early 1980s, and subsequently through the line-based work he has been producing since 1985.

Brice Marden's work is represented in most major international museum collections, as well as in important private collections. His work has been the subject of major one-person exhibitions organized by the Solomon R. Guggenheim Museum in New York; Stedelijk Museum in Amsterdam; Dia Center for the Arts in New York, Walker Art Center in Minneapolis, and The Menil Collection in Houston; Tate Gallery in London; Museum für Gegenwartskunst Basel; Kunsthalle Bern and Vienna Secession; and Staatliche Graphische Sammlung in Munich, Kunstmuseum Winterthur in Switzerland, and Fogg Art Museum, Harvard University, Cambridge. He has exhibited in important international and national exhibitions such as *Documenta* in Kassel, Germany, the Venice *Biennale,* the Whitney *Biennial,* and The Art Institute of Chicago's *American*s exhibitions. An extensive exhibition history and bibliography can be found at the back of this catalogue.

Works in the Exhibition

12.
Mask with Red, 1993–94
Oil on vellum stretched over
plywood, 23½ × 17⅝ in.
Brice Marden
(page 39)

13.
Calcium, 1993–95
Oil on linen, 71 × 57 in.
Private collection
(page 43)

14.
Skull with Thought, 1993–95
Oil on linen, 71 × 57 in.
Kathy and Keith Sachs
(page 46)

15.
Light in the Forest, 1993–95
Oil on linen, 71 × 53 in.
Frances and John Bowes
(page 47)

16.
The Golden Pelvic, 1993–95
Oil on linen, 71 × 57 in.
Mr. and Mrs. Richard S. Fuld, Jr.
(page 48)

17.
Progression, 1993–95
Oil on linen, 71 × 57 in.
Collection of Robert Lehrman,
Washington, D.C.
(page 49)

18.
Dance Glyphs, 1994
Oil on vellum stretched over plywood,
12⁹⁄₁₆ × 20¹⁄₁₆ in.
Mr. and Mrs. Richard S. Fuld, Jr.
(page 39)

19.
Little Red Painting, 1994
Oil on linen, 24 × 18 in.
Collection of Susan and David Gersh
(page 41)

20.
Suzhou, 1995–96
Oil on linen, 72 × 32 in.
Private collection, courtesy Thomas
Ammann Fine Art, Zurich
(page 50)

21.
Suzhou, Before and After, 1995–96
Oil on linen, 73 × 39 in.
Private collection
(page 51)

22.
Epitaph Painting 2, 1996–97
Oil on linen, 94 × 93½ in.
Private collection, New York
(page 54)

23.
Bear, 1996–97
Oil on linen, 84 × 60 in.
David Pincus
(page 55)

DRAWINGS
24.
Muses Drawing 4, 1989–91
Ink and gouache on paper,
26 × 40⅝ in.
Brice Marden
(page 24)

25.
Cold Mountain Addendum II, 1991–92
Ink and gouache on paper,
27⅞ × 34⅜ in.
Private collection
(page 20)

26.
Venus #2 (Negril), 1992–93
Ink on paper , 40½ × 25⅞ in.
Brice Marden
(page 34)

27.
Solstice, 1993
Ink and gouache on paper,
40½ × 26 in.
Helen Marden
(page 35)

28.
Eaglesmere Set, 4, 1996–97
Ink and gouache on paper,
17¹⁵⁄₁₆ × 12⅝ in.
Private collection
(page 64)

29.
Green Eaglesmere Set, 2, 1997
Colored ink wash, shellac ink on
paper, and gouache, 17⅝ × 12½ in.
Dr. and Mrs. Paul Sternberg,
Glencoe, Illinois
(page 63)

30.
Green Eaglesmere Set, 3, 1997
Colored ink wash, shellac ink on
paper, and gouache, 17⅝ × 12½ in.
Mr. and Mrs. Stanley R. Gumberg,
Pittsburgh
(page 63)

PRINTS
31.
Cold Mountain Series, Zen Study 1–6,
1991
Etching, aquatint, sugar-lift aquatint,
spit-bite aquatint, and scraping,
21 × 27½ in. (plate),
27½ × 35¼ in. (sheet)
Edition of 35
Matthew Marks Gallery, New York
(pages 21–23)

Selected Exhibitions

Exhibition entries and bibliography entries, which follow, are based partly on information found in *Brice Marden, Work Books: 1964–1995*, edited by Dieter Schwarz and Michael Semff (Düsseldorf: Richter Verlag, 1997) and *Brice Marden: Paintings and Drawings*, by Klaus Kertess (New York: Harry N. Abrams, 1992).

SELECTED ONE-PERSON EXHIBITIONS

1963
Brice Marden, The Wilcox Gallery, Swarthmore College, Swarthmore, Pennsylvania

1966
Brice Marden, Bykert Gallery, New York

1968
Brice Marden/Back Series, Bykert Gallery, New York

Drawings by Brice Marden, Bykert Gallery, New York

1969
Brice Marden: New Paintings, Bykert Gallery, New York

Brice Marden, Galerie Yvon Lambert, Paris

1970
Brice Marden, Galleria Françoise Lambert, Milan

Brice Marden, Bykert Gallery, New York

1971
Brice Marden: Bilder und Zeichnungen, Konrad Fischer, Düsseldorf

Brice Marden, Gian Enzo Sperone, Turin

1972
Brice Marden, Bykert Gallery, New York

Brice Marden: New Paintings, Locksley Shea Gallery, Minneapolis

Brice Marden, Konrad Fischer, Düsseldorf

1973
Brice Marden, Jack Glenn Gallery, Corona del Mar, California

Brice Marden, New Paintings: Grove Group, Bykert Gallery, New York

Brice Marden, Konrad Fischer, Düsseldorf

Brice Marden, Galerie Yvon Lambert, Paris

Brice Marden: Disegni, Galleria Françoise Lambert, Milan

1974

Brice Marden Drawings, 1964–1974, Contemporary Arts Museum, Houston; Gallery of the Loretto-Hilton Center, Webster College, St. Louis; Bykert Gallery, New York; Fort Worth Art Museum; The Minneapolis Institute of Arts

New Paintings, Brice Marden, Bykert Gallery, New York

12 Etchings by Brice Marden, Cirrus Gallery, Los Angeles

Brice Marden, The Jared Sable Gallery, Toronto

Brice Marden: Paintings, Drawings, Etchings, Locksley Shea Gallery, Minneapolis

1975

Brice Marden, Solomon R. Guggenheim Museum, New York

Brice Marden, Hester van Royen Gallery, London

Brice Marden: Shape Book, Konrad Fischer, Düsseldorf

Brice Marden, D'Alessándro/Ferranti, Rome

1976

Brice Marden, Galerie Yvon Lambert, Paris

Paintings and Drawings Made by Brice Marden, Sperone Westwater Fischer, Inc., New York

1977

Brice Marden: Drawings–Lithographs, Max Protetch Gallery, Washington, D.C.

Brice Marden: Works on Paper, David Winton Bell Gallery, Brown University, Providence, Rhode Island

Brice Marden: Etchings and Recent Drawings, Karen and Jean Bernier, Athens

Brice Marden, Gian Enzo Sperone, Rome

1978

Brice Marden: Recent Paintings and Drawings, The Pace Gallery, New York

1979

Brice Marden: Zeichnungen/Drawings 1964–1978, Kunstraum, Munich; Institut für Moderne Kunst, Nuremberg

1980

Brice Marden: Paintings and Drawings, Galerie Valeur, Nagoya, Japan

Brice Marden, InK, Halle für Internationale Neue Kunst, Zurich

Brice Marden: New Paintings, Konrad Fischer, Düsseldorf

Brice Marden, The Pace Gallery, New York

1981

Brice Marden: schilderijen, tekeningen, etsen 1975–1980, Stedelijk Museum, Amsterdam

Brice Marden: Paintings, Drawings and Prints 1975–1980, Whitechapel Art Gallery, London

1982

Brice Marden: Marbles, Paintings, and Drawings, The Pace Gallery, New York

1984

Brice Marden: Three Paintings 1964–1966, Raum für Malerei, Cologne

Brice Marden: Recent Work, The Pace Gallery, New York

Brice Marden: Paintings and Drawings, Daniel Weinberg Gallery, Los Angeles

1985

Brice Marden: Arbeiten auf Papier, Galerie Hock, Krefeld

1987

Brice Marden: New Paintings, Mary Boone/Michael Werner Gallery, New York

Brice Marden: Etchings to Rexroth, Hiram Butler Gallery, Houston

Brice Marden, Galerie Montenay, Paris

Brice Marden: Prints, Cirrus Gallery, Los Angeles

1988

Brice Marden, Mary Boone/Michael Werner Gallery, New York

Brice Marden: Recent Paintings & Drawings, Anthony d'Offay Gallery, London

Brice Marden: Prints, van Straaten Gallery, Chicago

1989

Brice Marden, Galerie Michael Werner, Cologne

1991

Brice Marden: The Grove Group, Gagosian Gallery, New York

Connections: Brice Marden, Museum of Fine Arts, Boston

Brice Marden: Recent Drawings and Etchings, Matthew Marks Gallery, New York

Brice Marden: Prints from the Early Seventies, Curwen Gallery, London

Brice Marden—Cold Mountain, Dia Center for the Arts, New York; Walker Art Center, Minneapolis; The Menil Collection, Houston; Museo Nacional Reina Sofía, Madrid; Städtisches Kunstmuseum Bonn

1992

Brice Marden Prints: 1961–1991, Tate Gallery, London; Musée d'Art Moderne de la Ville de Paris; The Baltimore Museum of Art

1993

Brice Marden: Paintings, Drawings, Etchings, Matthew Marks Gallery, New York

Brice Marden, Museum für Gegenwartskunst, Basel; Museum Fridericianum, Kassel

Brice Marden: Paintings 1985–1993, Kunsthalle, Bern; Vienna Secession; Stedelijk Museum, Amsterdam

Brice Marden: A Painting, Drawings, and Prints, The Saint Louis Art Museum

1994

Brice Marden: Etchings, Annemarie Verna, Zurich

1995

Brice Marden: Drawings 1964–1994, PaceWildenstein, New York

Brice Marden: New Paintings and Drawings, Matthew Marks Gallery, New York

1996

Brice Marden, Thomas Ammann Fine Art, Zurich

1997

Brice Marden: Two New Paintings with Five Tang Dynasty Epitaphs, Matthew Marks Gallery, New York

Brice Marden: Work Books 1964–1995, Staatliche Graphische Sammlung, Munich; Kunstmuseum Winterthur, Switzerland; Wexner Center for the Arts, The State University of Ohio, Columbus; Harvard University Art Museums, Cambridge, Massachusetts

1998

Brice Marden Drawings: The Whitney Museum of American Art Collection, Whitney Museum of American Art, New York

1999

Brice Marden, Work of the 1990s: Paintings, Drawings, and Prints, Dallas Museum of Art; Hirshhorn Museum and Sculpture Garden, Smithsonian Institution, Washington, D.C.; Miami Art Museum; Carnegie Museum of Art, Pittsburgh

SELECTED GROUP EXHIBITIONS

1960

The Second Competitive Drawing Exhibition, Lyman Allyn Museum, New London, Connecticut

1963

7 Yale Painters, Munson Gallery, New Haven, Connecticut

1965

Drawings Benefit: The Foundation for Contemporary Performance Arts, Leo Castelli Gallery, New York

1966

Park Place Invitational, Park Place Gallery, New York

1967

Drawings 1967, Ithaca College Museum of Art, Ithaca, New York

Contemporary American Painting and Sculpture 1967, Krannert Art Museum, University of Illinois at Urbana-Champaign

Gallery Group Show, Bykert Gallery, New York

A Romantic Minimalism, Institute of Contemporary Art, University of Pennsylvania, Philadelphia

Rejective Art, circulated under the auspices of The American Federation of Arts, New York, traveled to University of Omaha, Nebraska; The Museum of Fine Arts, Houston; Rudolph E. Lee Gallery, College of Architecture, Clemson University, Clemson, South Carolina

1968

Painting and Sculpture, Bykert Gallery, New York

1969

Concept, Vassar College Art Gallery, Poughkeepsie, New York

Prospect '69, Städtische Kunsthalle, Düsseldorf

Drawings: An Exhibition of American Drawings, Fort Worth Art Center Museum

1969 Annual Exhibition: Contemporary American Painting, Whitney Museum of American Art, New York

1970

Brice Marden/Bob Duran, Bykert Gallery, New York

The Drawing Society of New York Regional Exhibition: 1970, Cooper-Hewitt Museum of Decorative Arts and Design, Smithsonian Institution, New York, circulated nationally under the auspices of The American Federation of Arts, New York

Brice Marden–Jo Baer: Major Works, Gordon Locksley Gallery, Minneapolis

Modular Painting, Albright-Knox Art Gallery, Buffalo

Gallery Group Show, Bykert Gallery, New York

L'art vivant aux Etats-Unis, Fondation Maeght, Saint-Paul-de-Vence, France

American Drawings, Galerie Yvon Lambert, Paris

Drawings by New York Artists, Utah Museum of Fine Arts, University of Utah, Salt Lake City; Henry Art Gallery, University of Washington, Seattle; Arizona State University Art Museum, Tempe; Georgia Museum of Art, University of Georgia, Athens

Drawing Show, Janie C. Lee Gallery, Houston

1971

The Structure of Color, Whitney Museum of American Art, New York

Drawings USA/'71, Minnesota Museum of American Art, St. Paul

Lynda Benglis/Porfirio di Donna/ Sol LeWitt/Brice Marden/Dorothea Rockburne/Robert Ryman/Richard Tuttle, Bykert Gallery, New York

Drawings and Prints, Bykert Gallery, New York

Invitational, University Gallery, University of Massachusetts at Amherst

Aspects of Current Painting: New York, Memorial Art Gallery, University of Rochester, New York

White on White: The White Monochrome in the 20th Century, Museum of Contemporary Art, Chicago

1972

Painting: New Options, Walker Art Center, Minneapolis

Painting and Sculpture Today 1972, Indianapolis Museum of Art

Eight New York Painters, University of California Berkeley Art Museum

Drawings/72, Janie C. Lee Gallery, Houston

70th American Exhibition, The Art Institute of Chicago

Documenta 5, Kassel

Actualité d'un Bilan, Galerie Yvon Lambert, Paris

The Michener Collection: American Paintings of the Twentieth Century, Michener Galleries, University Art Museum, The University of Texas at Austin

1973

Gallery Group Show, Bykert Gallery, New York

1973 Biennial Exhibition: Contemporary American Art, Whitney Museum of American Art, New York

Arte come Arte, Centro Comunitario di Brera, Milan

Options and Alternatives: Some Directions in Recent Art, Yale University Art Gallery, New Haven, Connecticut

American Drawings 1963–1973, Whitney Museum of American Art, New York

Une exposition de peinture reunissant certains peintres qui mettraient la peinture en question, 16 Place Vendôme, Paris; International Cultural Centre, Antwerp; Städtisches Museum, Mönchengladbach, Germany

American Art: Third Quarter Century, Seattle Art Museum Pavilion

Prospect '73: Maler, Painters, Peintres, Städtische Kunsthalle, Düsseldorf

Art and Things: Painting in the Sixties from the Michener Collection, Michener Galleries, University Art Museum, The University of Texas at Austin

Contemporanea, Parcheggio di Villa Borghese, Rome

1974

Strata: Paintings, Drawings, and Prints by Ellsworth Kelly, Brice Marden, Agnes Martin, Robert Ryman, and Cy Twombly, Royal College of Art Galleries, London

Brice Marden: Etchings and Drawings/ David Novros: Paintings, Bykert Gallery, New York

Some Recent American Art, organized and circulated under the auspices of The International Council of The Museum of Modern Art, New York, traveled to National Gallery of Victoria, Melbourne; Art Gallery of New South Wales, Sydney; Art Gallery of South Australia, Adelaide; Art Gallery of West Australia, Perth; Auckland City Art Gallery

Geplante Malerei, Westfälischer Kunstverein Münster; Galleria del Milione, Milan

Five Artists: A Logic of Vision, Museum of Contemporary Art, Chicago

New Painting: Stressing Surface, Katonah Gallery, Katonah, New York

Continuing Abstraction in American Art, Whitney Museum of American Art, Downtown Branch, New York

Eight Contemporary Artists, The Museum of Modern Art, New York

1975

Color, organized under the auspices of The International Council of The Museum of Modern Art, New York, at the Museo de Arte Moderno de Bogotá

Carl Andre, Brice Marden, Bruce Nauman, Gian Enzo Sperone, New York

Fourteen Abstract Painters, Frederick S. Wight Art Gallery, University of California, Los Angeles

Marden, Novros, Rothko, Rice Museum and Sewall Gallery, Rice University, Houston

Fundamentele Schilderkunst/Fundamental Painting, Stedelijk Museum, Amsterdam

USA: Zeichnungen 3, Städtische Museum für modern Kunst, Schloss Morsbroich, Leverkusen, Germany

Funkties van tekenen/Functions of Drawing, Kröller-Müller Museum, Otterlo, Netherlands

Recent Drawings: William Allan, James Bishop, Vija Celmins, Brice Marden, Jim Nutt, Alan Saret, Pat Steir, Richard Tuttle, circulated under the auspices of The American Federation of Arts, New York; traveled to Gallery of Art, University of Alabama in Huntsville; The Art Museum, Princeton University,

Princeton, New Jersey; Cummer Museum of Art, Jacksonville, Florida

Tendances actuelles de la nouvelle peinture américaine, ARC₂, Musée d'Art Moderne de la Ville de Paris

Painting, Drawing, and Sculpture of the '60s and the '70s from the Dorothy and Herbert Vogel Collection, Institute of Contemporary Art, University of Pennsylvania, Philadelphia; The Contemporary Arts Center, Cincinnati

David Novros/Brice Marden, Texas Gallery, Houston

Drawings, Bykert Gallery, New York

Works on Paper, Greenberg Gallery of Contemporary Art, St. Louis

Prints, Art Gallery of Ontario, Toronto

Drawings, Margo Leavin Gallery, Los Angeles

1976

Drawing Now, The Museum of Modern Art, New York; circulated under the auspices of The International Council of The Museum of Modern Art, New York, traveled to Kunsthaus Zurich; Staatliche Kunsthalle, Baden-Baden; Graphische Sammlung Albertina, Vienna; Tel Aviv Museum of Art

72nd American Exhibition, The Art Institute of Chicago

Minimal Art: Druckgraphik, Kestner-Gesellschaft, Hannover

Three Decades of American Art Selected by the Whitney Museum, Seibu Museum of Art, Tokyo

American Artists: A New Decade, The Detroit Institute of Arts; Fort Worth Art Museum

1977

1977 Biennial Exhibition, Whitney Museum of American Art, New York

1978

Art About Art, Whitney Museum of American Art, New York; North Carolina Museum of Art, Raleigh; The Frederick S. Wight Art Gallery, University of California, Los Angeles; Portland Art Museum, Oregon

Late Twentieth-Century Art from The Sydney and Frances Lewis Foundation Collection, Anderson Gallery, School of the Arts, Virginia Commonwealth University, Richmond, circulated nationally through May 1983

American Painting of the 1970s, Albright-Knox Art Gallery, Buffalo; Newport Harbor Art Museum, Newport Beach, California; Oakland Museum of California; Cincinnati Art Museum; Art Museum of South Texas, Corpus Christi; Krannert Art Museum, University of Illinois, Champaign

Grids: Format and Image in 20th Century Art, The Pace Gallery, New York; Akron Art Museum, Ohio

1979

1979 Biennial Exhibition, Whitney Museum of American Art, New York

The Reductive Object, Institute of Contemporary Art, Boston

The Minimal Tradition, The Aldrich Museum of Contemporary Art, Ridgefield, Connecticut

The 1970s: New American Painting, organized by The New Museum of Contemporary Art, New York, and the International Communication Agency, circulated internationally through 1980

1980

Dessins de la Fondation Maeght, Fondation Maeght, Saint-Paul-de-Vence, France

Sammlung Panza, Städtische Kunsthalle, Düsseldorf

American Drawing in Black and White 1970–1980, Brooklyn Museum of Art

1981

A New Spirit in Painting, Royal Academy of Arts, London

20 Artists: Yale School of Art 1950–1970, Yale University Art Gallery, New Haven Connecticut

Amerikanische Malerei 1930–1980, Haus der Kunst, Munich

De Picasso à Sol LeWitt: 80 dessins du Musée de Grenoble, Musée des Beaux-Arts, Calais

1982

Surveying the Seventies, Whitney Museum of American Art, Fairfield County, Connecticut

'60–'80: Attitudes/Concepts/Images, Stedelijk Museum, Amsterdam

Abstract Drawings, 1911–1981, Whitney Museum of American Art, New York

The Americans: The Collage, Contemporary Arts Museum, Houston

1983

Abstract Painting: 1960–69, P.S. 1 Contemporary Art Center, Long Island City, New York

Affinities: Myron Stout, Bill Jensen, Brice Marden, Terry Winters, Hayden Gallery, Massachusetts Institute of Technology, Cambridge

Minimalism to Expressionism: Painting and Sculpture Since 1965, Whitney Museum of American Art, New York

Mangold, Marden, Ryman, Paula Cooper Gallery, New York

The First Show: Painting and Sculpture from Eight Collections 1940–1980, The Museum of Contemporary Art/The Temporary Contemporary, Los Angeles

In Honor of de Kooning, Xavier Four-
cade, New York

1984

*The Tremaine Collection: 20th Century
Masters—The Spirit of Modernism*,
Wadsworth Atheneum, Hartford,
Connecticut

American Art Since 1970, organized
under the auspices of the National
Committee of the Whitney Museum
of American Art, New York, traveled
to La Jolla Museum of Contempo-
rary Art, La Jolla, California; Museo
Tamayo, Mexico City; North Caro-
lina Museum of Art, Raleigh; Shel-
don Memorial Art Gallery, University
of Nebraska-Lincoln; Center for the
Fine Arts, Miami

The Meditative Surface, The Renais-
sance Society at the University of
Chicago

*La rime et la raison: Les collections
Menil (Houston–New York)*, Galeries
Nationales du Grand Palais, Paris

*La Grande Parade: Highlights in
Painting After 1940*, Stedelijk
Museum, Amsterdam

1985

*Selections from the William J. Hokin
Collection*, Museum of Contempo-
rary Art, Chicago

*Fifty Years of American Drawing:
1930–1980*, organized by The Menil
Collection, Houston, traveled to
Ecole Nationale Supérieure des
Beaux-Arts, Paris; Städtische Galerie
im Städelsches Kunstinstitut,
Frankfurt

*Painterly Visions, 1940–1984: The
Guggenheim Museum Collection
and Major Loans*, Solomon R.
Guggenheim Museum, New York

*Von Twombly bis Clemente: Selected
Works from a Private Collection*,
Kunsthalle Basel

*Georg Baselitz/Joseph Beuys/Brice
Marden*, Mary Boone/Michael
Werner Gallery, New York

1985 Carnegie International, Carnegie
Museum of Art, Pittsburgh

1986

*An American Renaissance: Painting
and Sculpture Since 1940*, Museum
of Art, Fort Lauderdale

The Barry Lowen Collection, The
Museum of Contemporary Art,
Los Angeles

*Major Acquisitions Since 1980: Selected
Paintings and Sculpture*, Whitney
Museum of American Art, New York

*The Spiritual in Art: Abstract Paint-
ing 1890–1985*, Los Angeles County
Museum of Art; Museum of Con-
temporary Art, Chicago; Haags
Gemeentemuseum, The Hague

*Individuals: A Selected History of
Contemporary Art, 1945–1986*,
The Museum of Contemporary Art,
Los Angeles

*Abstrakte Malerei aus Amerika und
Europa*, Galerie Nächst St. Stephan,
Vienna

Art Minimal II: De la surface au plan,
CAPC Musée d'Art Contemporain,
Bordeaux

1987

Works on Paper, Anthony d'Offay
Gallery, London

*The Menil Collection: A Selection from
the Paleolithic to the Modern Era*,
The Menil Collection, Houston

1988

*Fifty Years of Collecting: An Anniver-
sary Selection—Painting Since World
War II: North America*, Solomon R.
Guggenheim Museum, New York

*Amerikkalaista Nykytaidetta/Ameri-
kansk Samtidskunst/Contemporary
American Art*, Sara Hilden Art
Museum, Tampere, Finland; Kunst-
nernes Hus, Oslo

*La couleur seule: l'experience du mono-
chrome*, Musée d'Art Contemporain,
Lyons

1988 Carnegie International, Carnegie
Museum of Art, Pittsburgh

1989

*Bilderstreit: Widerspruch, Einheit,
und Fragment in der Kunst seit 1960*,
organized by the Museum Ludwig,
Cologne, at Rheinhallen der Kölner
Messe, Cologne

1989 Biennial Exhibition, Whitney
Museum of American Art, New York

*Art in Place: Fifteen Years of Acquisi-
tions*, Whitney Museum of American
Art, New York

*Abstraction, Geometry, Painting:
Selected Geometric Abstract Paint-
ing in America Since 1945*, Albright-
Knox Art Gallery, Buffalo; Center for
the Fine Arts, Miami; Milwaukee Art
Museum; Yale University Art Gallery,
New Haven, Connecticut

1990

Seven American Artists, Vivian Horan
Fine Art, New York

American Masters of the 60's, Tony
Shafrazi Gallery, New York

Minimal Art, BlumHelman Gallery,
New York

Minimalist Prints, Susan Sheehan
Gallery, Inc., New York

*Concept Art, Minimal Art, Arte povera,
Land Art: Slg. Marzona*, Kunsthalle
Bielefeld, Germany

*Brice Marden/Samuel Buri/Ernst
Messerli: Projekte für das Basler
Münster*, Kunsthalle Palazzo, Liestal,
Switzerland

*Amerikanische Zeichnungen in den
Achtziger Jahren*, Graphische
Sammlung Albertina, Vienna;
Museum Morsbroich, Leverkusen,
Germany

Polyptiques, Musée du Louvre, Paris

Le Diaphane, Musée des Beaux-Arts, Tourcoing, France

Master Drawings 1520–1990, organized by Janie C. Lee Master Drawings, New York, and Kate Ganz Ltd., London, 63 Thompson Street, New York

1991

An Overview of Drawing, David Nolan, New York

Bildlicht: Malerie zwischen Material und Immaterialität, Museum des 20. Jahrhunderts, Vienna

Strategies for the Next Painting, Jamie Wolff Gallery, New York; Feigen, Incorporated, Chicago

Artists' Sketchbooks, Matthew Marks Gallery, New York

Dead Heroes, Lorence Monk, New York

Kulturen-Verwandtschaften in Geist und Form, Galerie Nächst St. Stephan/Rosemarie Schwarzwalder, Vienna

1992

Jasper Johns/Brice Marden/Terry Winters: Drawings, Margo Leavin Gallery, Los Angeles

Marking the Decades: Prints 1960– 1990, The Baltimore Museum of Art

Slow Art, P.S. 1 Contemporary Art Center, Long Island City, New York

Documenta IX, Kassel

Allegories of Modernism: Contemporary Drawing, The Museum of Modern Art, New York

1993

American Art in the 20th Century, Martin-Gropius-Bau, Berlin; Royal Academy, London

Timely and Timeless, The Aldrich Museum of Contemporary Art, Ridgefield, Connecticut

New Etchings, Margo Leavin Gallery, Los Angeles

1994

The Ossuary, Luhring Augustine Gallery, New York

From Minimal to Conceptual Art: Works from The Dorothy and Herbert Vogel Collection, National Gallery of Art, Washington, D.C.

1995

About Place: Recent Art of the Americas, The Art Institute of Chicago

ARS 95, Museum of Contemporary Art, Finnish National Gallery, Helsinki

Painting–Singular Object, The National Museum of Modern Art, Tokyo; The National Museum of Modern Art, Kyoto

Diary of a Human Hand: Betty Goodwin, Brice Marden, Agnes Martin, Susan Rothenberg, Galerie du Centre des Arts Saidye Bronfman, Montreal

1995 Whitney Biennial, Whitney Museum of American Art, New York

Du trait à la ligne, Galerie d'art graphique, Musée national d'art moderne, Centre Georges Pompidou, Paris

Meisterwerke aus dem Kupferstichkabinett Basel, "zu Ende gezeichnet": Bildhafte Zeichnungen von der Zeit Dürers und Holbeins bis zur Gegenwart, Westfälisches Landesmuseum, Münster

1996

The Robert and Jane Meyerhoff Collection: 1945 to 1995, National Gallery of Art, Washington D.C.

In the Shadow of Storms: Art in the Postwar Era from the MCA Collection, Museum of Contemporary Art, Chicago

In Quest of the Absolute, Peter Blum Edition, New York

1997

Judd Marden Ryman–Prints, Susan Sheehan Gallery, New York

Color and Paper/Von Farben und Papieren, Galerie Nächst St. Stephan/ Rosemarie Schwarzwalder, Vienna

Die Sammlung Anne-Marie und Ernst Vischer-Wadler: Ein Vermächtnis, Kunstmuseum Basel

Biennale, Venice

1998

Master Drawings of the 20th Century, Mitchell-Innes & Nash, New York

Painting: Now and Forever, Pat Hearn/ Matthew Marks Galleries, New York

Selected Bibliography

Brice Marden. New York: The Solomon R. Guggenheim Foundation, 1975 (Linda Shearer, "Brice Marden's Paintings").

Brice Marden: Recent Paintings and Drawings. New York: The Pace Gallery, 1978 (Jean-Claude Lebensztejn, "From").

Brice Marden: Zeichnungen/Drawings 1964–1978. Munich: Kunstraum München, 1979 (Hermann Kern, "Brice Marden: Painter and Graphic Artist"; Klaus Kertess, "The Drawings of Brice Marden").

Brice Marden: Paintings, Drawings and Prints 1975–1980. London: Whitechapel Art Gallery, 1981 (Nicholas Serota, "The Edge: The Balancing Point"; Stephen Bann, "Brice Marden: From the Material to the Immaterial"; Roberta Smith, "Brice Marden"; Brice Marden, "Selected Statements, notes and interviews").

Brice Marden: Marbles, Paintings, and Drawings. New York: The Pace Gallery, 1982 (William Zimmer, "Marden 1982: Hermeticism Made Visible").

Brice Marden: Recent Work. New York: The Pace Gallery, 1984.

Brice Marden. Paris: Galerie Montenay, 1987 (Jean-Claude Lebensztejn, "Sans titre (océanique)"; Klaus Kertess, "Drawing Conclusions").

Brice Marden: New Paintings. New York: Mary Boone/Michael Werner Gallery, 1987 (Peter Schjeldahl, "Marrying Abstraction").

Brice Marden: Recent Paintings & Drawings. London: Anthony d'Offay Gallery, 1988 (John Yau, "A Vision of the Unsayable").

Brice Marden/Samuel Buri/Ernst Messerli: Projekte für das Basler Münster. Liestal, Switzerland: Kunsthalle Palazzo, 1990 (Philip Ursprung, "Brice Marden's Entwürfe der Chorscheiben des Basler Münsters").

Brice Marden: Cold Mountain Studies. Edition Heiner Bastian, vol. 4. Munich, Paris, London: Schirmer/Mosel, 1991 (Heiner Bastian, "Notes").

Brice Marden: The Grove Group. Introduction by Robert Pincus-Witten. New York: Gagosian Gallery, 1991 (Brice Marden, "The Grove Group Notebook").

Brice Marden: Recent Drawings and Etchings. New York: Matthew Marks Gallery, 1991 (interview by Pat Steir).

Brice Marden. Basel: Öffentliche Kunstsammlung Basel, Museum für Gegenwartskunst, 1993 (Dieter Koepplin, "Brice Marden: Basler Münsterscheiben, Cold Mountain—The transformation, that's what it's about").

Brice Marden: Paintings 1985–1993. Bern: Kunsthalle Bern and Wiener Secession, 1993. (Ulrich Loock, "On Shifts in the Work"; Yve-Alain Bois, "Marden's Doubt").

Brice Marden: Paintings, Drawings, Etchings. New York: Matthew Marks Gallery, 1993.

Brice Marden. New York: Matthew Marks Gallery, 1995 (essay by David Rimanelli).

Brice Marden: Drawings 1964–1994. New York: PaceWildenstein, 1995.

Brice Marden. Zurich: Thomas Ammann Fine Art, 1996 (Brice Marden, "Souvenir de Grèce 1974/96").

Brice Marden: Work Books 1964–1995. Düsseldorf: Richter Verlag, 1997.

Brice Marden: Chinese Work. New York: Matthew Marks Gallery, 1998 (Jonathan Hay, "Marden's Choice" and interview).

Dickhoff, Wilfried. *Brice Marden.* Cologne: Michael Werner, 1989.

Fairbrother, Trevor. *Brice Marden: Boston.* A "Connections" Project at the Museum of Fine Arts, Boston 1991. Boston: Museum of Fine Arts, Boston, 1991 (Robert Creeley, "Notes For Brice Marden"; John Yau, "Words For and From Brice Marden"; Patti Smith, "Upon a Star"; Brice Marden, "Past–Recent–Now").

Jasper Johns/Brice Marden/Terry Winters: Drawings. Los Angeles: Margo Leavin Gallery, 1992 (essay by Jeremy Gilbert-Rolfe).

Kertess, Klaus, *Brice Marden: Paintings and Drawings.* New York: Harry N. Abrams, 1992.

Lewison, Jeremy. *Brice Marden Prints 1961–1991.* London: The Tate Gallery, 1992.

Marden, Brice. *Suicide Notes.* Lausanne: Editions des Massons, 1974.

Marden, Brice. *Reporters Notebook: Drawings Made in Greece, Summer 1981.* New York: Pace Gallery Publications, 1984.

Nodelman, Sheldon. *Marden, Novros, Rothko: Painting in the Age of Actuality.* Houston: Institute for the Arts, Rice University, 1978.

Richardson, Brenda. *Brice Marden: Cold Mountain.* Houston: Houston Fine Art Press, 1992.

ABOUT THE AUTHOR

Since February 1996, Charles Wylie has been The Lupe Murchison Curator of Contemporary Art at the Dallas Museum of Art. He received his bachelor of arts in American studies from the University of Notre Dame, and his master of arts degree in the history of art from Williams College. In Dallas he has organized exhibitions of the work of Matthew McCaslin, Linda Ridgway, and Patrick Faulhaber. From 1992 to 1996, he was assistant curator of contemporary art at The Saint Louis Art Museum, where he organized exhibitions of the work of numerous artists, including Roni Horn, Thomas Struth, and Willie Cole, and the exhibition *"It's a Tough World Out There": Drawings by Mike Kelley, Joyce Pensato, and Raymond Pettibon*. Prior to St. Louis, Mr. Wylie worked at Lannan Foundation in Los Angeles and was a graduate intern in the Department of Photographs at the J. Paul Getty Museum.